"William Bollman's
vintage photo album is a real treasure.
It brings L. Frank's words to life
with his stories in Tamawaca Folks
and turn of the century photos."

Gita Dorothy Morena
Great Granddaughter of L. Frank Baum

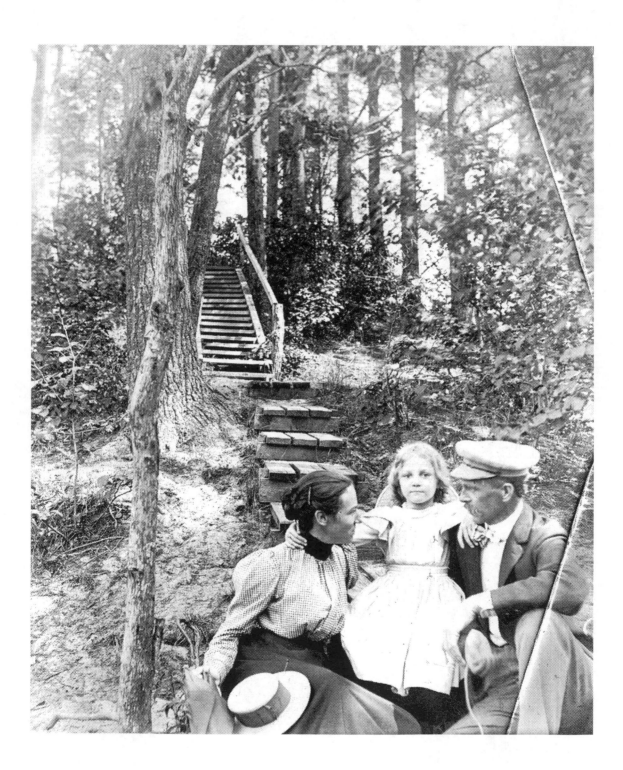

Imagine if you will, a family out for an afternoon walk. The path is a wooden walkway through the forested sand dunes along the shore of Lake Michigan at a place called Macatawa Park. The year is 1899. A young couple with their daughter stop and pose for a quick snapshot from a Kodak #2 Box camera held by a young lady. In the distance two men are strolling along the wooded path. They are deep in conversation, their hands gesturing and pointing as they look at various things along the path. One man has a small pad of paper, which he occasionally makes quick sketches in. They pause upon seeing the family posing for a snapshot. When the family resumes their leisurely stroll, the two men give a polite nod as they pass each other. A quick smile and both groups are on their way.

Imagine if you will another scene, only this time 110 years later at an estate sale, where Mr. William Bollman is thumbing through some old family photo albums. One volume in particular catches his eye. It contains photos taken at a summer resort on Lake Michigan called Macatawa Park. The pictures taken so long ago, talk to him.

You see Macatawa Park was the summer home of L. Frank Baum, the author of "*The Wonderful Wizard of Oz.*" The album of pictures before Mr. Bollman was a window to that past time. The little story and the chance meeting on the board walk are just a moment of imagination. Or are they? All the people were real and they were in the same place at the same time!

The book you hold in your hands is truly OZ-some! The vintage pictures of L. Frank's Macatawa are a real window to the past and William Bollman's use of 'Tamawaca Folks' as the theme for the photographs makes my great grandfather's books all that much more real and important. I do not think L. Frank Baum was aware of just how much Macatawa would influence his work. Many point to such similarities as found in the wooden plank paths of the 'Lovers Lane'

pictures and the Yellow Brick Road. Or as you travel along the wooded paths, W. W. Denslow's pictures of Dorothy and her fearless group entering the dark forest who's trees seem to be closing in on them at the beginning of The Wonderful Wizard of Oz.

As I look at all of the wonderful pictures in this book, I can just imagine Denslow and Baum on that wooden path gesturing and writing down ideas for a new Wonderful tale, or L. Frank and his wife Maud, hand in hand, walking to a meeting at the Auditorium. I want to thank William Bollman for making this trip back in time possible and hope all of you love it as much as I have!

ROBERT A. BAUM
Great grandson of L. Frank Baum

VINTAGE PHOTO ALBUM SERIES™

1899

L.FRANK BAUM's
OZ-Inspiring Macatawa Park

WILLIAM BOLLMAN

FOREWORD BY ROGER S. BAUM

Order this book online at www.trafford.com
or email orders@trafford.com

Most Trafford titles are also available at major online book retailers.

Printed in the United States of America.

ISBN: 978-1-4669-8316-8 (sc)
ISBN: 978-1-4669-8317-5 (e)

Library of Congress Control Number: 2013903864

Trafford rev. 03/12/2013

 www.trafford.com

North America & international
toll-free: 1 888 232 4444 (USA & Canada)
phone: 250 383 6864 ♦ fax: 812 355 4082

CONTENTS

To my kids:

Abigail Bollman
Ally Bollman
&
John Bollman.

FOREWORD

This book will bring the reader to Macatawa Park, Michigan, a favorite vacation place of my great grandfather. As you read it you will begin to hear a slice of the laughter emanating from the sights of this beautiful spot nestled on the shore of Lake Michigan. In this Trip Back In Time: Vintage Photo Album™, you will begin to hear the voices of long-gone citizens. You will hear the whispering roar of this great lake as it blew across the bow of the steamer "Soo City," just now leaving for a night departure from Chicago to Holland, Michigan. Later as you near the shore you might even catch a glimpse of the Macatawa Hotel which, great grandmother said, "Looked a lot like the famous Hotel Del Coronado," where she and great grandfather used to vacation in San Diego, California. She admitted it did have certain architecture similar in many places to the famous San Diego hotel: the steep of its roof, the window coverings, the railings and even more that contributed to her memory of Macatawa Park. You'll hear the wind picking up a loose board or two on the boardwalk of this most beautiful and quaint vacation place. You can hear it in the pictures from Hattie's Kodak No. 2 camera in 1899.

Did I say, 'Hear the wind?' Yes, I certainly did. There is a haunting to the vintage photos. Perhaps you'll find a copy of great grandfather's book titled, "Father Goose," lying next to a copy of "The Wonderful Wizard of Oz," at the local library. Or a picture nearby of Hattie A. Talcott who preserved the sights you'll find within this fascinating and lovely book by William Bollman.

This book is not only inspirational, but its release could not be better for us today, as we grasp frantically for the heritage of our great country.

See the sights, hear the wind and touch the people of this inland sea resort, as you enter the Macatawa Bay Yacht Club and meet everyone. "Hello Mr. Jarrod and Mr. and Mrs. Wilder, I believe? Ah yes, and it's good to see you too, Mr. Easton. By the way folks, is that L. Frank Baum and his lovely wife Maud, standing over there by the table? It could be."

Thank you, Mr. Bollman for the pleasant vacation. Please give my best to the rest of the folks in Tamawaca Park.

ROGER STANTON BAUM
Author

PROLOGUE

The TRIP BACK IN TIME: Vintage Photo Album Series™ of books is quite unique. Most photo books about historical places provide photos taken over many years, some old, some more recent, and most photos having been published before. Each book in the TRIP BACK IN TIME: Vintage Photo Album Series™ instead explores an extraordinary amateur vintage photo album of photos generally from ONE year, of a given location, trip or subject, and always having never been published before. Every vintage photo album tells its own unique story; the older the photo album the more challenging it is to uncover the details of its story.

This entry in the TRIP BACK IN TIME: Vintage Photo Album Series™ focuses on Hattie A. Talcott's photo album of her summer more than 110 years ago in Macatawa Park, Michigan. She traveled by horse cab to Chicago, and boarded a steamer with her family to travel overnight with much of Chicago's high society across Lake Michigan. Their destination was a mystical summer region in Michigan called Macatawa Park. The year was 1899.

Hattie's 1899 vintage photo album

Hattie's vintage photo album contains over 125 fantastic and extremely rare images of historic Macatawa Park, Michigan, all taken in 1899. It was recently uncovered at an estate auction in the New York City area. Hattie inscribed her vintage photo album to her husband, Charles, as:

C.H. Talcott,
Joliet, Ill.
Many Happy Memories of the day
with best wishes,
Hattie, Aug. 1899.

Hattie used a turn-of-the-century Kodak No. 2 wooden box camera, most probably a Kodak No. 2 Bulls-Eye camera, circa 1898, as seen in several photos in her vintage photo album. At first Kodak No. 2 cameras before the turn of the century came preloaded with a large roll film, some capable of taking up to 100 photos, but the entire camera had to be shipped back to the factory for processing and re-loading with more film. Later models used a film cartridge system.

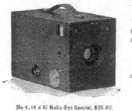

"There is no Kodak but the Eastman Kodak."

Kodak Photography Is Easy Photography

It means picture taking minus the dark room, minus troublesome plate holders, minus heavy and fragile glass plates.

All 1898 Kodaks use light-proof film cartridges and can be

Loaded in Daylight.

No. 2, 3½ x 3½ Bulls-Eye Special, $15.00.

Rapid rectilinear lenses, triple action shutters, iris diaphragm stops and the film cartridge system are all combined in the

Bulls-Eye Special Kodaks.

KODAKS $5.00 to $35.00.

Catalogues free at Kodak agencies or by mail.

EASTMAN KODAK CO.

Rochester, N. Y.

No 4, ¼ x 5½ Bulls-Eye Special, $20.00.

Advertisement for Kodak No. 2 Bulls-Eye cameras circa 1898

The Kodak No. 2 Bulls-Eye camera circa 1899 was a lightweight wooden box camera which took 101 size roll film. Various models cost between $5 and $35 in 1898. Box cameras like Hattie's didn't have a zoom lens as do today's modern cameras, so you had to walk right up to a subject to frame them properly. A Kodak No. 2 wooden box camera can be seen on the next page in a photo from Macatawa Park's Lovers Lane, taken by Hattie in 1899.

Cyanotypes

The photos in Hattie's photo album are 4 inch square cyanotype prints. Cyanotype or blueprint photographs are *blue* and white images, which were popular with amateur photographers in the late 19th century. They were easy to make and could be developed and fixed with water.

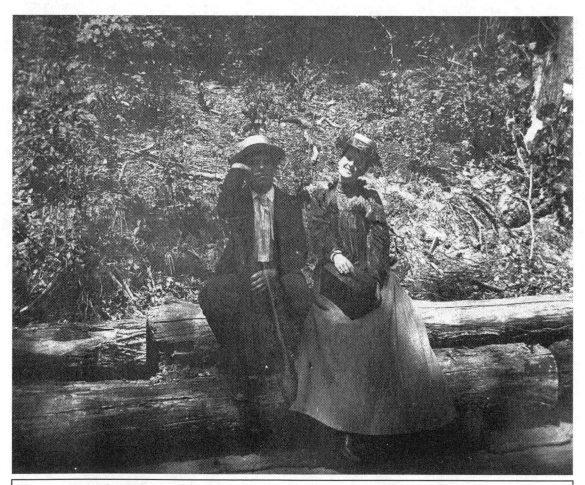

Along the board walk (believed to be Lovers Lane), Macatawa, Mich.
Bob Keith and Louise B. Norton, 51 (of Chicago, Ill.), Macatawa, Mich.

Hattie's photos are incredibly well taken for the time. And not only that, they show the buildings, board walks, cottages, boats, beach, auditorium, annual regatta, and even the Venetian Evening, and other places and events in the infamous "Tamawaca" that L. Frank Baum described and wrote so eloquently and accurately about in his great classic summer comedy *"Tamawaca Folks"*, published in 1907. Hattie made her vintage photo album before *"Tamawaca Folks"* was published, but at the beginning of the era in which L. Frank Baum summered in Macatawa Park. L. Frank Baum spent many summers in Macatawa Park, first visiting it in 1899, exactly when these photos were taken.

Hattie fortuitously documented the very Macatawa Park that provided L. Frank Baum with what he himself called a "fairyland" environment as he was conceptualizing and writing his beloved *"The Wonderful Wizard of Oz"*. It's also the very Macatawa Park that provided L. Frank Baum with the subject matter for *"Tamawaca Folks"*. Now, more than 110 years later, we are provided with a once-in-a-lifetime opportunity to visualize that which L. Frank Baum saw at the turn of the century as he wrote those timeless books. So, to tell the story of the photos in this entry in the Vintage Photo Album Series™, it seems there can be no one better than L. Frank Baum himself.

L. Frank Baum

L. Frank Baum moved to Chicago in 1891, after several failed attempts in other professions. He had become such a fantastic storyteller to his sons that by 1897 his mother-in-law encouraged him to write down the nursery rhymes he had improvised, which he did, and *"Mother Goose in Prose"* published to rave reviews. In 1899, the same year as Hattie's vintage photo album, he collaborated with Chicago cartoonist and poster designer W. W. Denslow on what would be his breakout hit, *"Father Goose: His Book,"* which was the best-selling book of that year with an estimated 175,000

copies sold. During the summer of 1899, "*Father Goose*" was complete though still being illustrated by his collaborator Denslow. This very same summer, L. Frank Baum first spent a few weeks in Macatawa Park, and was writing his next book, the beloved "*The Wonderful Wizard of Oz.*"

Macatawa Park is thought to have provided inspiration to L. Frank Baum for significant elements of "*The Wonderful Wizard of Oz,*" which would seem to reason as he first fell in love with what he himself called his "fairyland" as he wrote about the Land of Oz. For instance, in a research paper written in 1995, The Joint Archives of Holland History Research Center in Holland, Michigan suggests that **Munchkinland** was modeled after a group of cottages at Macatawa Park called Perry's Circle. A young girl at Macatawa Park named **Dorothy** Hall has been suggested as having been the inspiration for the legendary heroine. Dorothy Hall (who lived to be 98) spoke of how L. Frank Baum told her the story of "*The Wonderful Wizard of Oz,*" replacing the word "Dorothy" in the story with "you." Ms. Hall was only 2 years old in 1899, which some have said casts doubt that she was the original inspiration for Dorothy, but it does seem very likely that SOMEBODY at Macatawa Park provided inspiration for Dorothy. (More about that later) The winding cobblestone streets of nearby Holland, Michigan, which had a golden sheen in the fall, are known to have provided the inspiration for the **Yellow Brick Road**. And the grandeur of the "White City" at the Chicago World's Fair of 1893 from whence the journey to Macatawa Park began by steamer for both L. Frank Baum and Hattie A. Talcott, is known to have provided the inspiration for the **Emerald City**.

"*Tamawaca Folks*" is a satire about the real-life town of Macatawa Park, and tells the story of Jarrod, a Kansas City lawyer who comes to town for the summer. He finds it a beautiful place, but soon learns that its developers, Wilder and Easton, are corrupt frauds. Wilder is an extroverted businessman, while his partner Easton is elderly and pious. Jarrod learns that the partners have built cottages in the middle of the public street,

and let all the board walks fall to ruin. There is also a romantic subplot in which a young man finds his way to personal happiness.

Wilder and Easton were based on real-life chief stockholders of Macatawa Park at the time, Fred K. Colby and E. C. Westervelde. Jarrod was based on an actual Kansas City lawyer who arrived in town, Basil P. Finley. Baum also included a minor parody of himself. Baum authored "*Tamawaca Folks*" under a pseudonym, but his authorship of the book, concealed at first, was soon guessed at by the people involved, all in good spirit.

L. Frank Baum's 100+ year old story "*Tamawaca Folks*" brings Hattie's vintage photos to life. In this entry in the TRIP BACK IN TIME: Vintage Photo Album Series™ we are honored and humbled to have Mr. L. Frank Baum himself tell the story, using an abridged version of "*Tamawaca Folks*" illustrated appropriately with Hattie's photos. Hattie's own descriptions are included in *italics* below relevant photos, with any additional commentary by the author included non-italicized.

All photos in Hattie's album were taken in 1899 unless otherwise noted, and all in the Macatawa Park area. And in the spirit of all books in this Vintage Photo Album Series™, **NONE of the photos from Hattie's vintage photo album have ever been published before.**

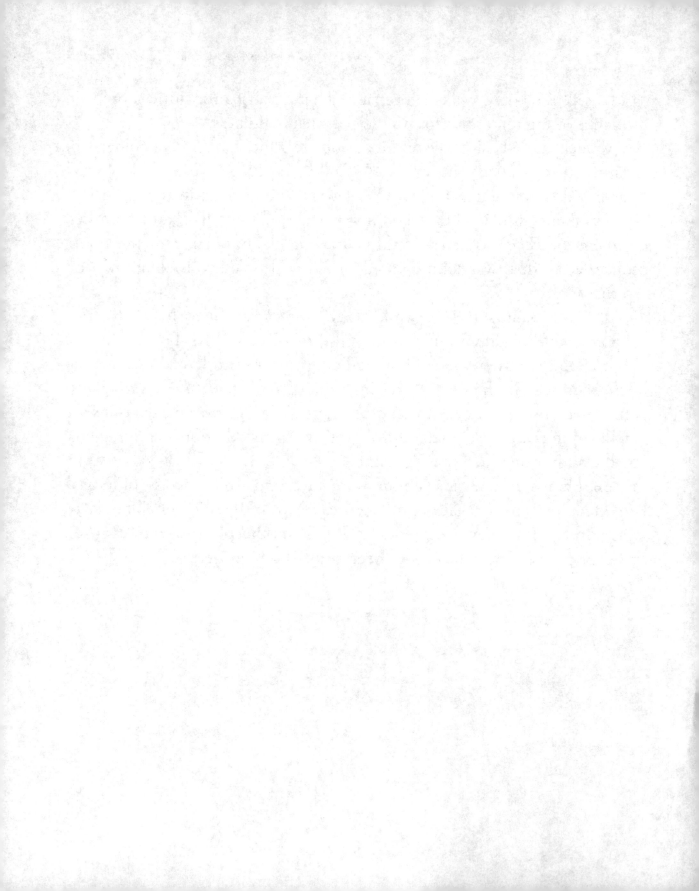

TAMAWACA FOLKS

By L. Frank Baum
Featuring Hattie's vintage photos from 1899

EXPLANATIVE

Tamawaca exists, and is as beautiful as I have described it. I chose it as the scene of my story because I once passed an entire summer there and was fascinated by its incomparable charm. The middle West has no spot that can compete with it in loveliness.

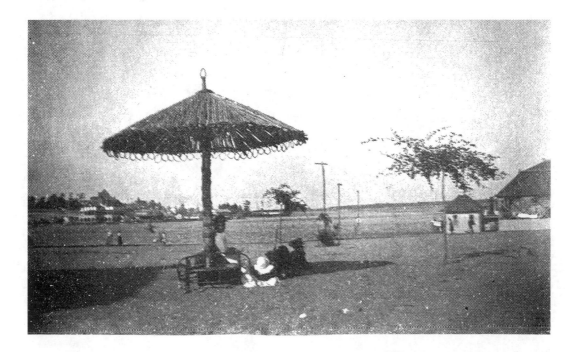

TAMAWACA FOLKS

When Jarrod finally sold out the Crosbys he had a chance to breathe freely for the first time in years. The Crosbys had been big ranch owners and herders, mine owners, timber and mill owners, bankers, brokers, bucket-shop manipulators and confirmed bull-dozers and confidence-men. They played the game for big stakes always and won by sheer nerve and audacity. Jarrod was their lawyer and they kept him in hot water every minute.

As fate would have it, on a balmy spring day he met an old friend—a Dr. Brush—who was a prominent and highly respected clergyman. Said the doctor:

"You need a change, Jarrod. Why don't you go to some quiet, pleasant summer resort, and loaf until fall?" said Dr. Brush.

"Where can I find such a place?" asked Jarrod.

"Why, any of the Lake Michigan resorts are desirable—Tamawaca, Bay View, Charlevoix or Petoskey. I've been to Tamawaca a couple summers myself, and like it immensely. It is n't so fashionable as Charlevoix and Petoskey, but it is the most beautiful place I have ever seen, bar none."

"What's there?" enquired Jarrod, listlessly

"Lake Michigan, to begin with; and Tamawaca Pool, which is really a lovely inland lake. You'll find there good fishing and bathing, a noble forest running down to the water's edge, pretty cottages, nestled among the trees, lots of ozone, and quiet till you can't rest."

"Eh?"

"I mean quiet so you CAN rest."

"It sounds quite promising," said Jarrod. "Guess I'll go. My wife remarked yesterday we ought to escape the summer's heat on the children's account. This idea will please her-and it pleases me. And hunt. How's the hotel, Brush?"

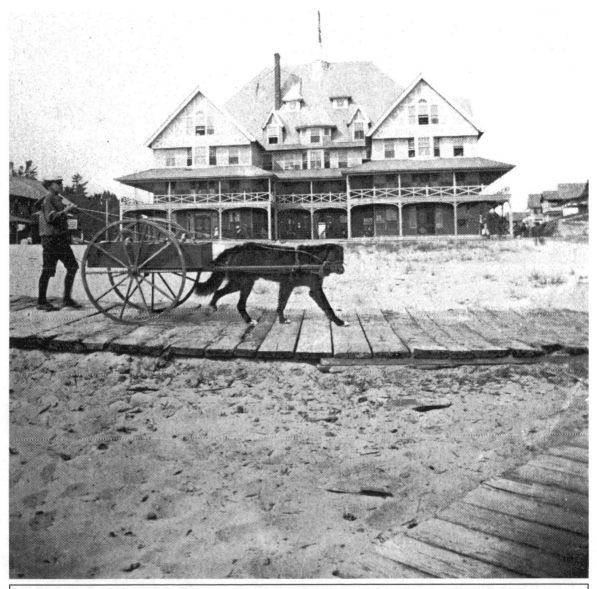

Macatawa Hotel, Macatawa Park, MI, recently built in 1885, with board walks passing in front

"Bad as possible. Take a cottage. That's the only way to enjoy life."

"How can I get a cottage?"

"Oh, ask Wilder, when you get to Tamawaca. There are always cottages to rent. But stay! you might take Grant's place. He's a St. Louis man, and I understand his cottage is for rent."

"Thank you very much."

"Who is Wilder?" Jarrod asked his friend.

"Wilder! Oh, I forgot you don't know Tamawaca," said Dr. Brush. "Therefore you don't know Wilder. Wilder is Tamawaca."

"I see," returned Jarrod, nodding.

"Oh, no you don't. You *think* you see, I've no doubt. But there is only one Wilder upon earth, and perhaps that is fortunate. You've been in with those pirate Crosbys for years. Well, Wilder is the Crosby—in other words the pirate—of Tamawaca. See now?"

"He runs things, eh?"

"Yes; for Wilder."

A few days later the Jarrods—bag and baggage, parents and children-travelled up to Chicago and landed in the morning at the Auditorium Annex. A little fat man stood before the counter in front of Jarrod and winked saucily at the clerk.

"Gimme the best room you have," he called out, while scribbling his name on the register.

"Ah, a twenty-dollar suite?" asked the clerk, cheerfully.

"Hear me out!" retorted the little man. "Gimme the best room you have for four dollars a day."

"Oh," said the clerk, his jaw dropping. "Here, front! show the gentleman up to 1906. Any baggage, sir?"

"Just my wife," sighed the little man, with another wink, and a stout lady of ample proportions grabbed his arm and whisked him away. She did n't seem at all offended, but laughed pleasantly and said: "Now, George, behave yourself!"

Jarrod looked at the register. The little fat man had written: "Geo. B. Still, Quincy, Ill."

The Jarrods shopped during the day, and bought themselves and the children cool things for summer. In the evening they went down to the river and boarded the big steel steamer that was to carry them to their destination.

A whistle blew; the little tug strained at its cable, and snorting and puffing in the supreme struggle it drew the great steamer "Plymouth" away from its dock to begin its journey down the river to the open lake and thence, discarding its tug, across mighty Michigan to Iroquois Bay, Tamawaca, and the quaint city of Kochton.

The steamer Soo City of the Holland and Chicago line opened the season around May 1, 1899, taking the 7pm night departure from the foot of State Street in Chicago, and the morning departure from Holland, and had a good season in 1899. Single fare was $2.25 one-way, $3.50 round trip. The weather was good, and the country was rapidly emerging from the depression of the 1890s toward the Edwardian prosperity.

The passengers thronged both the ample decks to catch the cooling breeze that came as soon as they were in motion, for the day had been especially warm for June. The older folds drew long lines of chairs to the rails, while the young people walked up and down, chattering and gay. To nearly all the voyage meant the beginning of a holiday, and hearts were light and faces eager and expectant.

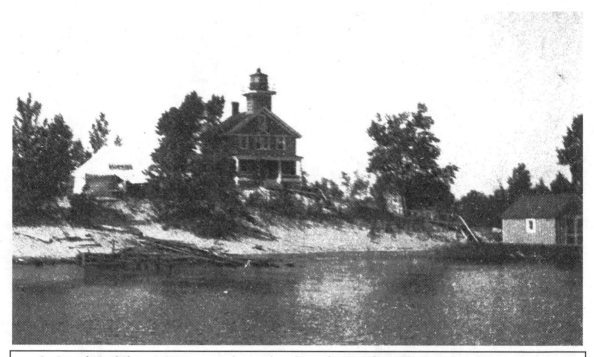

<u>St. Joseph Lighthouse (in St. Joseph, Mich., along the way from Chicago to Macatawa Park)</u>

St. Joseph's first Federal lighthouse was constructed in 1859 on the hill above the harbor, and served the area until 1906 when the north pier was extended 1,000 feet, and the cast iron pier head light installed. With the construction of the pier light, the Lighthouse Service decided to decommission the 1859 structure, however after much objection from local mariners, the old light remained in service until 1924, when it was officially retired.

Jarrod had no sooner located his family in a comfortable corner than he was attracted by a young man who sauntered by.

"Why, Jim, is it you? he exclaimed, jumping up to hold out a hand in greeting.

The other paused, as if astonished, but then said in a cordial tone:

"You here, Mr. Jarrod?"

He was a tall, athletic looking fellow, with a fine face. Jarrod had recognized him as the only son of a man he had known in St. Louis-a man very prominent and wealthy, he remembered.

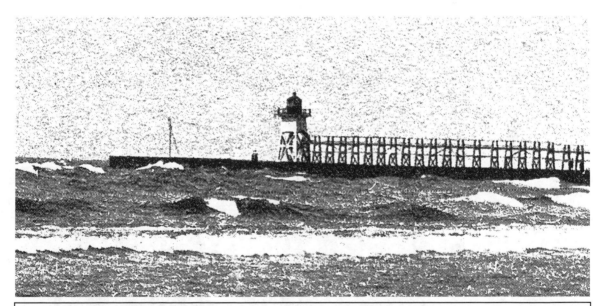

The Original Holland Lighthouse at the channel along Macatawa Park was erected with $4,000 of federal funds in 1872, twenty years before the harbor was complete. It was a small, square, wooden structure that stood on an open platform on legs above the deck of the South Pier Head. On top was a lantern deck with a ten-window lantern room, and has been reported to have used a 5th order light. The lighthouse keeper had to carry his lighted oil lamp along a wooden catwalk on top of the pier, which stretched from the shore where he lived to the lamp under a lens or magnifying device. When fog obscured the light, incoming boats were signaled by blowing an 18 inch fish horn often used on sailboats. Just two years after this photo was taken the wooden tower was replaced by a taller, steel structure which housed the lamp.

"What are you doing here, Jim?" he enquired.

"Why, I live in Chicago now, you know," was the reply.

"You do?"

"Did n't you know, sir? I left home over a year ago. I'm hoeing my own row now, Mr. Jarrod."

"What's wrong, Jim?"

"Father and I couldn't agree. He wanted me to take to the patent medicine business, because he has made a fortune in it."

"Very natural," nodding.

"The poor father suffers a good deal from rheumatism, you know; so as soon as I left college he proposed to turn over to me the manufacture and sale of his great rheumatism cure."

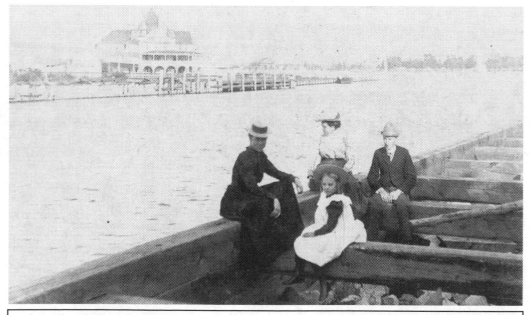

Along the channel leading from Lake Michigan into Black Lake (later Lake Macatawa).

"Ah."

"And I balked, Mr. Jarrod. I said the proprietor of a rheumatism cure had no business to suffer from rheumatism, or else no business to sell the swindling remedy.

"To be sure. I know your father, Jim, so I can imagine what happened, directly you made that statement. Did he give you anything when you—er—parted?"

"Not a sou. I'm earning my own living."

"Good. But how?"

"They don't take a boy just out of college for the president of a bank or the director of a railway. I'm just a clerk in Marshall Field's."

"How much do you earn?" asked the lawyer, quietly.

"Twelve dollars a week. But it's an interesting experience, Mr. Jarrod. You've no idea how well a fellow can live on twelve dollars a week—unless you've tried it."

Jarrod smiled.

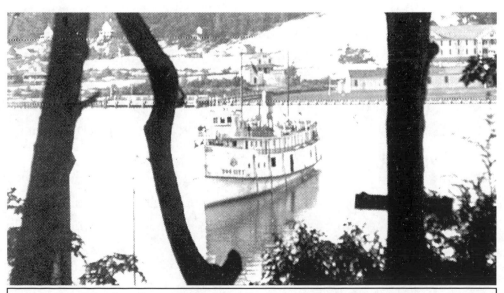

The Soo City pulling up to the dock at Macatawa Park, MI

Owing to continued cold weather in 1899, the resort season at Macatawa Park was a little late in starting and as a result the crowds at the hotels were small until about July 30. Then, encouraged by warm days, people began coming on every boat and incoming train until August 23rd, when Hotel Macatawa was filled with guests.

"Where are you bound for?" Jarrod asked.

"A little place called Tamawaca, there to spend my two weeks' vacation. Just think of it! After fourteen months I've saved enough for an outing. It isn't a princely sum, to be sure-nothing like what I spent in a day at college-but by economy I can make it do me in that out-of-the-way place, where the hotel board is unusually cheap."

"I'm told it is as bad as it is cheap," said Jarrod.

"That stands to reason, sir. I'm not expecting much but rest and sunshine and fresh air-and perhaps a nice girl to dance with in the evening."

"I see."

"And, by the way, Mr. Jarrod," this with some hesitation, "please don't tell anyone who I am, if you're asked. I call myself James Ingram-Ingram was my mother's name, you know-and I'd rather people would n't know who my father is, or why I'm living in this modest way. They would either blame me or pity me, and I won't endure either from strangers, for it's none of their business."

Good night, Mr. Jarrod."

The young man walked on, and the lawyer looked after him approvingly.

In drawing a chair to the rail he found that seated beside him was the little fat man he had noticed at the Annex. This jovial individual was smoking a big cigar and leaning back contentedly with his feet against the bulwark. Jarrod thought the expression upon the round face invited companionship.

"Going to Tamawaca?" he asked.

"Yep," said Geo. B. Still.

"Been there before?" continued Jarrod, leaning back in turn.

"Yep. Own a cottage there."

"Oh," said the other; "then I'm glad to meet you."

"Because I own a cottage?"

"No; because you can tell me something about the place."

"Sure thing!" responded Geo. B. "Climate's fine. That Tamawaca climate's a peach."

"Do you think I can rent a cottage there?"

"Sure. Ask Wilder. He'll fix you."

"Is there a grocery handy, where one can purchase supplies?"

"Yep. Wilder runs it."

"And a meat market?"

"Wilder's."

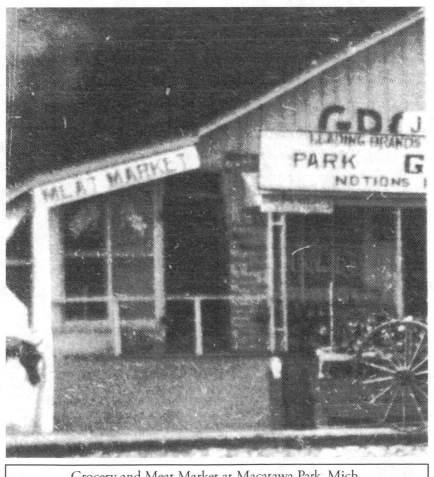

Grocery and Meat Market at Macatawa Park, Mich.

"Can I rent a good boat, for fishing?"
"Wilder has 'em."

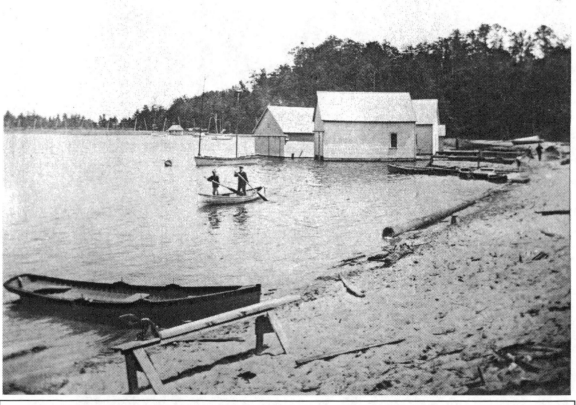

Boat Livery, Macatawa Park, Mich.

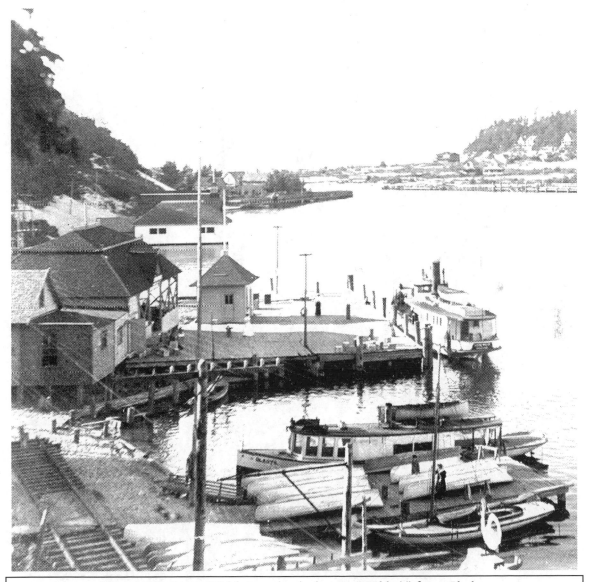

The steamer Lizzie Walsh is at the dock, as is "Wilder's" ferry Gladys.

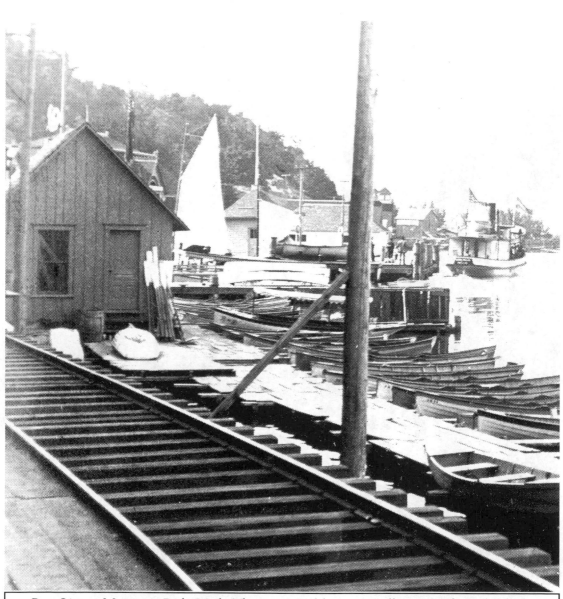

Boat Livery, Macatawa Park, Mich. The Lizzie Walsh is seen pulling away from the dock.

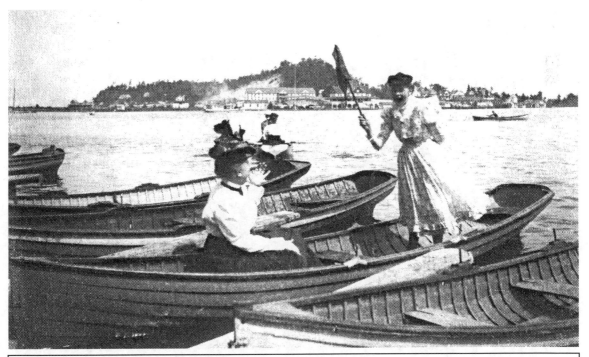

Jennie Heath, 47, (unmarried, of Joliet, Ill.), and Ethel Folk, 12, (of Joliet, Ill.)
(Note the Hotel Ottawa at Ottawa Beach (aka 'Iroquois Bay' in "Tamawaca Folks") in the
background, and Mt. Pisgah, the large dune, behind that.)

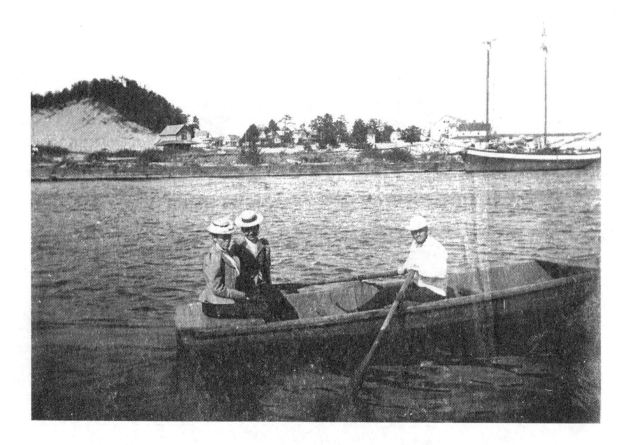

"Good. Dear me! I forgot to get a bathing suit in Chicago."

"Never mind. Wilder's Bazaar has 'em. Two dollars for the dollar kind."

"What time does the boat get to Tamawaca."

"Four o'clock in the morning. But you stay on board and ride to Kochton, and get your sleep out. Then, in the morning you take a trolley back to Tam.

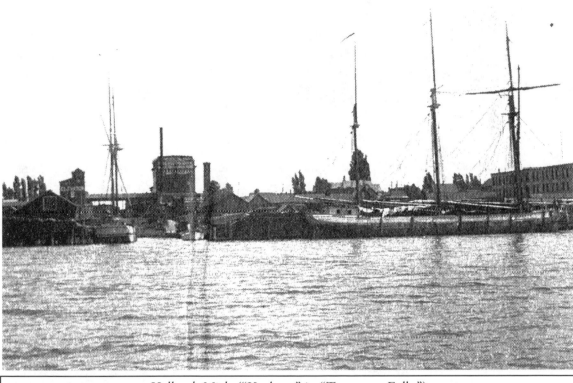

Holland, Mich. ("Kochton" in "Tamawaca Folks")

The steamer puts your baggage off at Iroquois Bay, just across the channel."

"What becomes of it?"

"Wilder ferries it over for twenty-five cents a piece. It's too far to jump."

"But is n't that a heavy charge?"

"Not for Wilder. It's a good deal, of course, but Wilder's deals are always good-for Wilder. You're lucky he don't take the baggage."

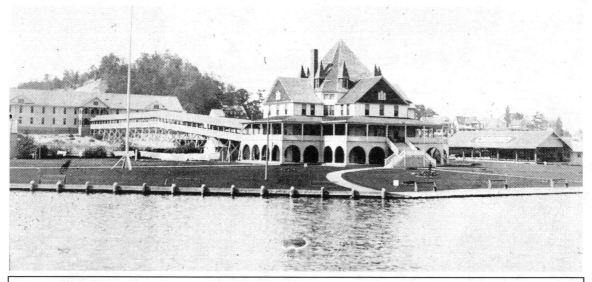

Ottawa Beach Hotel and Casino. "CASINO" can be seen on the roof of the building on the right. This is L. Frank Baum's "Iroquois Bay, just across the channel." It was constructed in 1886 and significantly enlarged 2 years after this photo, in 1901.

"Therefore, if you want Tamawaca, sir, you've just got to take Wilder with it," resumed the little man; "and perhaps you could n't be half so happy there if Wilder was gone."

"Does he own the place?"

"Of course. He and old man Easton."

Tamawaca's the gem of the world-a heaven for loafers, lovers, bridge-players and students of nature-including human. You'll like it there. But as for Wilder and Easton-say! any combination lock on your inside pocket?"

"When Jarrod arrived at Tamawaca in the course of the next forenoon he found all prophecies most amply fulfilled. Fronting the beautiful bay was a group of frame buildings bearing various signs of one general trend: "Wilder's Grocery;" "Wilder's Ice Cream and Soda Fountain;" "Wilders

Model Market;" "Wilders Boat Livery;" "Wilder's Post Office" (leased to Uncle Sam;) "Wilder's Bakery;" "Wilder's Fresh-Buttered Pop-Corn;" "Wilder's Bazaar;" "Wilder's Real Estate Office," etc., etc.

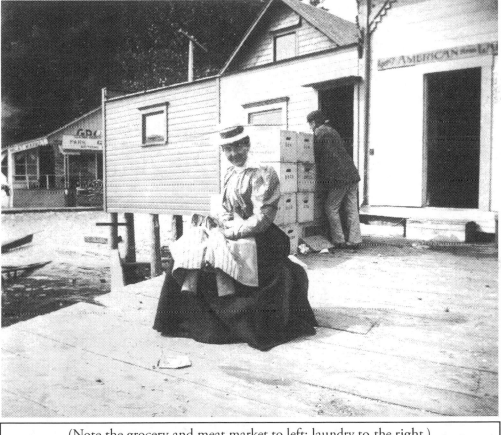

(Note the grocery and meat market to left; laundry to the right.)

As the lawyer helped his family off the car a man dashed out of the grocery, ran up to him and seized both his hands in a welcoming grip. He was a stocky built, middle sized man, with round features chubby and merry, a small mouth, good teeth, and soft brown eyes that ought to have been set in a woman's face.

"My dear, *dear* boy. I'm delighted to see you—indeed I am! Welcome to Tamawaca," said the man, in a cordial, cheery tone. "And these are the

dear children! My, my—how they *have* grown! And Mrs. Jenkins, too, I declare!"

"Pardon me," said the lawyer, a little stiffly; "my name is Jarrod."

"Of course—of course!" cried Wilder, unabashed. "Nora, my dear, help me to welcome our good friends the Jarrods, that Dr. Brush has written us about. How nice to see you at last in lovely Tamawaca!"

"I want to enquire about Grant's cottage. He says you have the rental of it."

Wilder's face fell, and his merry expression gave way to one of absolute despair.

"Dear me!" he exclaimed, as if deeply distressed; "how very unfortunate. Grant's cottage was rented only last evening. How sad that I did not know you wanted it!"

"But there are others, of course," suggested Jarrod, after a moment's thought.

"Let-me-see," mused Wilder, reflectively. "There's the Stakes place-but that's rented; and Kimball's is gone, too; and Smith's, and Johnson's, and McGraw's-all rented and occupied. My dear boy, I'm afraid you're up against it. There is n't a cottage left in Tamawaca to rent! But never mind; you shall stay with me—you and the wife and the dear little ones. I live over the grocery, you know—really swell apartments. You shall stay there as my guests, and you'll be very welcome, I assure you.

"Oh, I can't do that, Wilder," said Jarrod, much annoyed. They had strolled, by this time, to the porch of the grocery and bazaar-a long building facing the bay on one side and the hotel on the other. It had wide porches set with tables for the convenience of consumers of ice-cream sodas. Inside, the building was divided into the meat market, the grocery and the bazaar, all opening on to the same porch.

Bazaar, Macatawa Park, Mich.

Jarrod sat down at one of the tables, feeling homeless and despondent.

"Ah!" cried Wilder, slapping the table with emphasis; "I have it! You are saved, dear boy-and not only saved but highly favored by fortune. How lucky I happened to think of it!"

"What is it?" asked Jarrod, with reviving interest.

"Why, I've got Lake View for sale, the prettiest and finest cottage in the whole Park. You shall have it, dear boy-you shall have it for a song."

"But I don't want to buy a cottage," protested Jarrod. "I've not even seen Tamawaca yet, and I don't know as I'll like it."

"Not like it! Not like Tamawaca!" Wilder's voice was sad and reproachful. "My dear boy, *everybody* likes Tamawaca. You can't help liking it.

"Come, I'll show you thc charms of our little heaven upon earth, and at the same time you shall examine lovely 'Lake View.'"

Let us walk over to the Lake front, and I'll astonish you with the beauty of our fairyland."

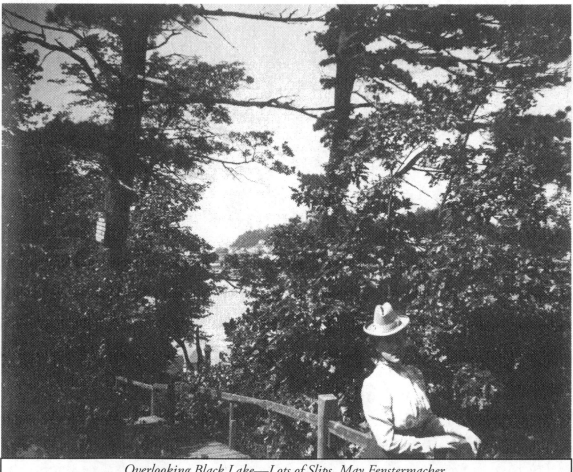

Overlooking Black Lake—Lots of Slips. May Fenstermacher.
(Black Lake changed its name to Macatawa Bay in 1935)

So Jarrod, leaving his family to be entertained by Mrs. Wilder, who seemed an eminently fitting spouse for her cheery husband, followed this modern Poo-Bah along a broad cement walk that led past the hotel and through a shady grove. There were cottages on every side, clustered all too thickly to be very enticing, but neatly built and pleasant enough for a summer's outing.

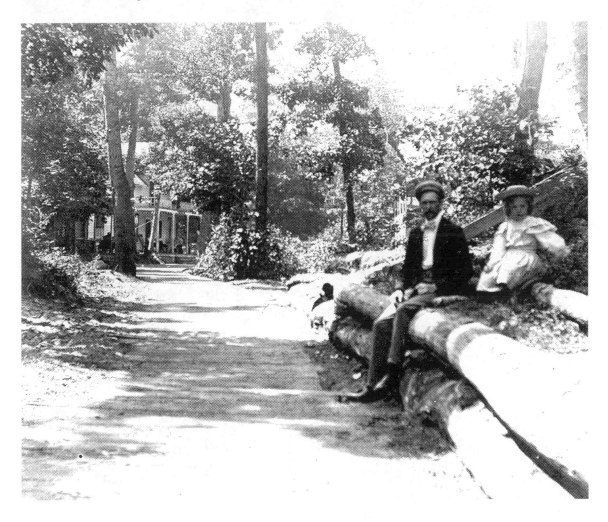

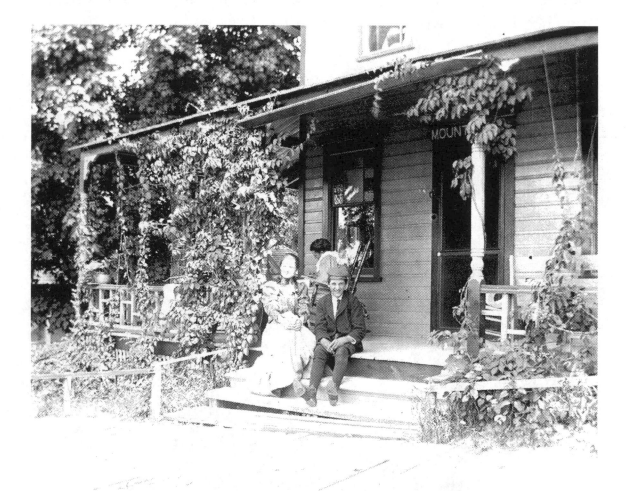

A few paces more brought them to a magnificent view of the great inland sea, and soon they emerged upon a broad beach lapped by the rolling waves of grand old Michigan.

Overlooking Black Lake (Note the Hotel Ottawa through trees to the left.)

Jarrod's eyes sparkled. It *was* beautiful at this point, he was forced to admit, and the cool breath of the breeze that swept over the waters sent an exhilarating vigor to the bottom of his lungs and brought a sudden glow to his cheek.

Along the lake front was another row of pretty cottages, running north and south for a distance of half a mile or more. At frequent intervals an avenue led from the beach back into the splendid forest, where, Wilder explained, were many more cottages hidden among the trees.

"Some people prefer to live in the forest," said he, "while others like to be nearer the water. The cottage you have just bought is near the big lake, and finely located."

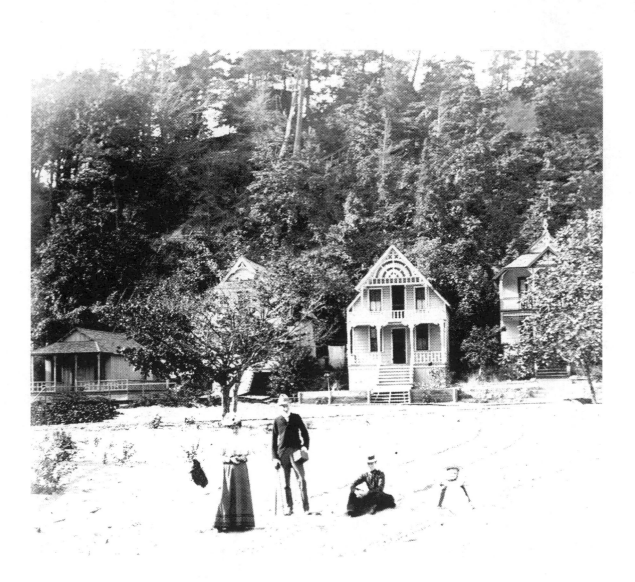

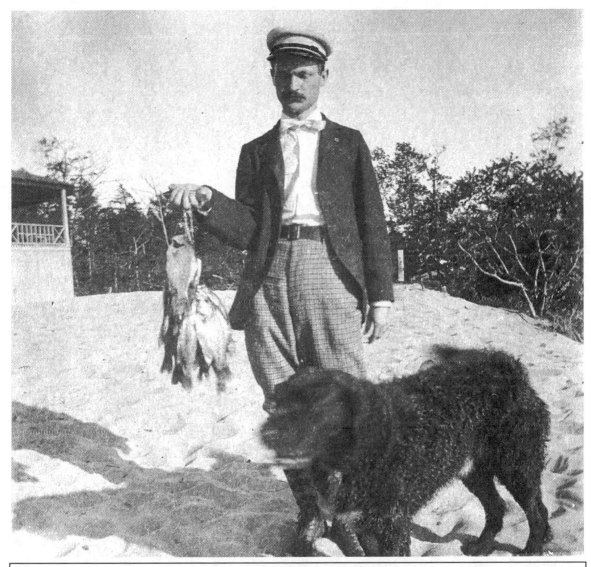

Macatawa Park, Mich. Will Fletcher, 38 (of Williamson, Ill.), Jumbo Talcott
Black bass, pickerel and perch were plentiful.

"Here," continued the guide, as they went south along the wide beach walk, "is the residence of the Father of Tamawaca, my dear partner Mr. Easton." He stumbled on a loose, worn out plank, and came to a halt.

"This walk, dear boy, ought to be repaired. I've talked to Easton about it more than once, but he says he's too poor to squander money on public improvements."

"Who owns the street?" enquired Jarrod.

"Why, we own it, of course—Easton and I. You see, this whole place was once a farm and some men bought it and laid out and platted Tamawaca Park. They incorporated under the laws of Michigan as a

summer resort company, and so they kept the control of all the streets and public grounds in their own hands. It's a private settlement, you understand, and when a man buys one of the lots he acquires the right to walk over our streets as much as he likes-as long as he behaves himself."

"And if he does n't?"

"If he does n't we can order him off."

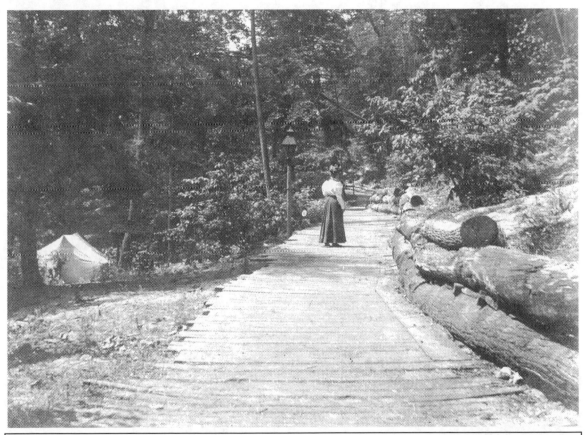

This avenue of the board walks is believed to be "Lovers Lane", Macatawa, Mich. Note the tent in the woods to the left, a vestige of the earliest days of Macatawa as a destination resort, particularly before the Hotel Macatawa was built in 1895. In the early days of Macatawa Park there were many tents on the grounds, said to add to the picturesque features of the scene, renting furnished as early as 1884 for $2 to $2.50 per week.

"Was the original plat recorded?" asked Jarrod.

"Yes; of course."

"With the streets and public grounds laid out in detail?"

"Certainly."

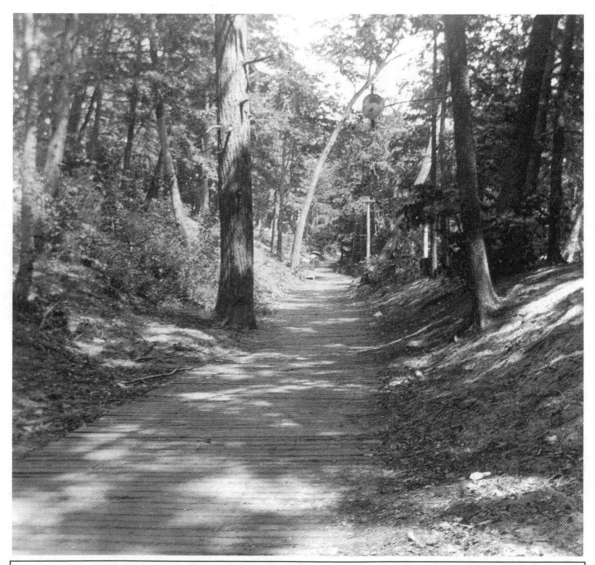

This avenue of the board walks is believed to be "Golden Gate Walk", Macatawa, Mich.

"Then," said the lawyer, "the first man that bought a lot here acquired a title to all your public streets and grounds, and you lost the control of them forever."

"Nonsense!" cried Wilder.

"I've read law a bit," said Jarrod, "and I know."

"Michigan law is different, dear boy," announced Wilder, composedly. "Still we mean to do what's right, and to treat every cottage owner fair and square—as long as he does what we tell him to."

Jarrod's face was beaming. He had not been so highly amused for months—not since the Crosbys had sold out. He had n't seen Lake View Cottage as yet, but already he had decided to buy it. A condition that would have induced an ordinary man to turn tail and avoid Tamawaca was an irresistible charm to this legal pugilist. But his cue was now to be silent and let Wilder talk.

"Here, dear boy," that seraphic individual was explaining, "is where Noggs lives, the wealthy merchant prince of Grand Rapids. And here's the cottage of our distinguished author. Don't have to work, you know. Just writes books and people buy 'em. Snap, ain't it?"

"Looks that way," said Jarrod. "What's that cottage standing in the middle of yonder avenue?"

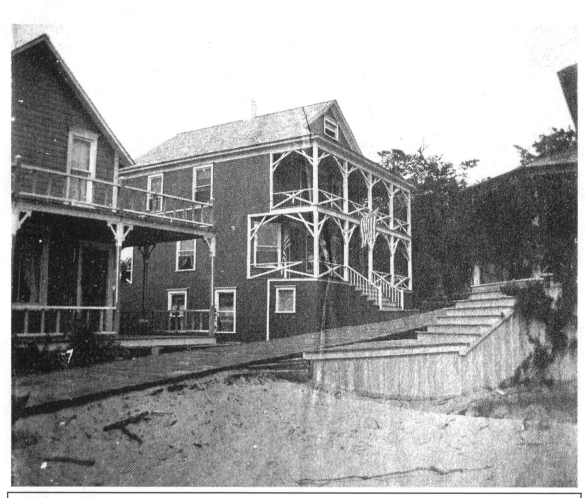

Waukazoo Trail showing the Ledeboer Cottage, and the Uneeda Rest Cottage, both built in 1891, Macatawa Park, Mich. These cottages were located directly up the hill, and just a few houses away, from L. Frank Baum's "The Sign of the Goose," which he built at the foot of Nahant Path.

"Oh, that belongs to old man Easton."

"Why is it there?"

"Why, lake front lots are scarce, you know; but cottages on the lake front rent for good money. So Easton built one in the street, and rents it at a high figure. Clever scheme, ain't it?"

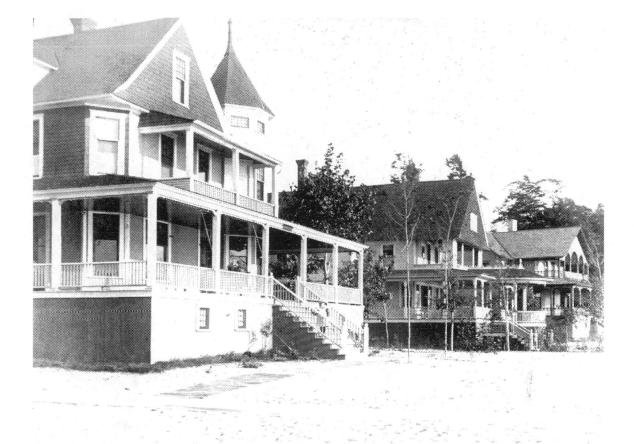

"Did n't the cottage owners object?"

"It was built in the winter, when no one was here. When the resorters came in the spring and saw it, they wailed an' tore their hair. But it was too late, then. While they swore, Easton prayed for 'em; he's religious. The old saint's got lots o' cottages on public grounds, but no one can make him tear 'em down because we control the public grounds ourselves. Whatever's public here belongs to me an' Easton. Understand?"

"Perfectly."

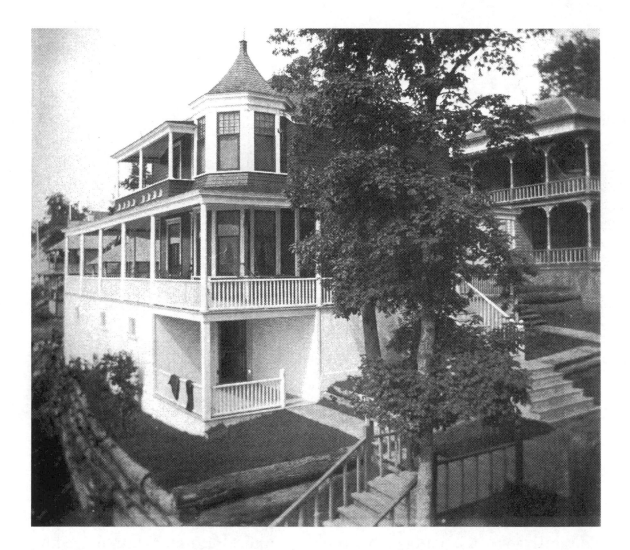

"Here's where the big stock-yards man from Chicago lives. Pretty place, eh? And here's the cottage of George B. Still, the magnate of Quincy."

"Here we are at Maple Walk—one of the most picturesque avenues in town. Please climb these few steps; it is on this walk your charming cottage stands."

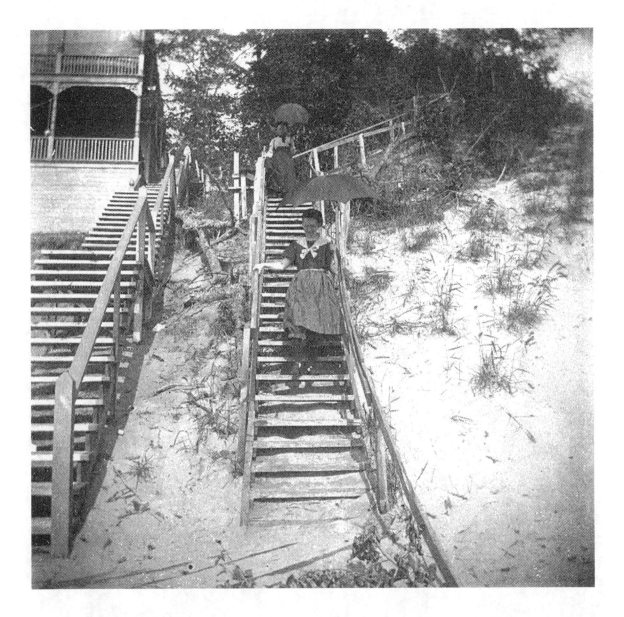

Jarrod liked the place. It was high enough to command an outlook upon the lake and to catch every breeze, yet not too high for an ordinary climb.

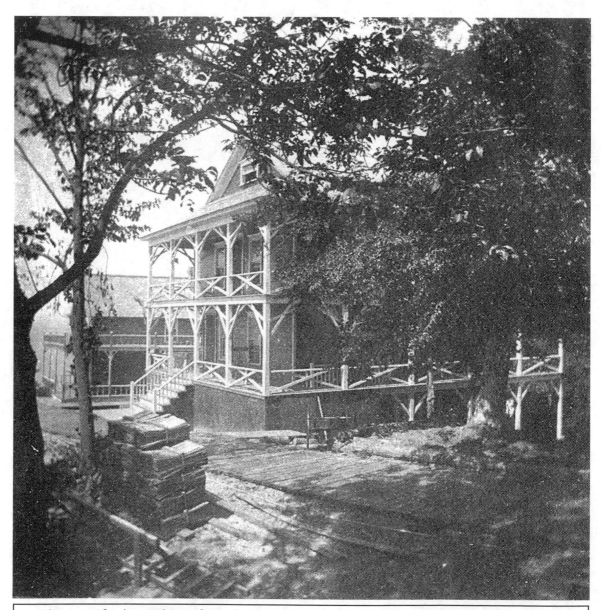

The view of Lake Michigan from the Uneeda Rest Cottage in this exact direction would have looked directly over the roof of L. Frank Baum's cottage "The Sign of the Goose."

"Is the cottage on the lot?"

"Why do you ask?"

"It don't look it."

"Never mind that. I'll sell you the lot and the cottage. If the house is n't on the lot it's somewhere in the neighborhood, and no one's going to ask any questions."

"Why not?"

"Because they don't dare n't. They're all in the same boat. There has n't been a surveyor allowed in Tamawaca for ages."

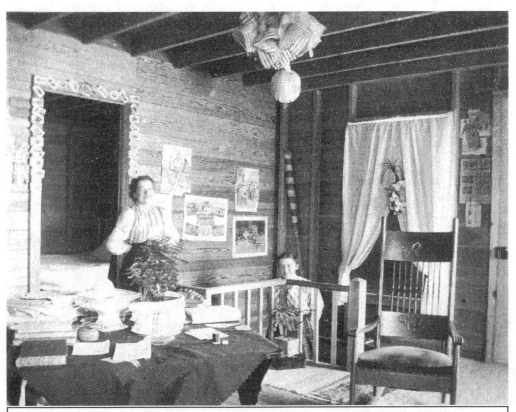

Living Room of Uneeda Rest Cottage, Macatawa Park, Michigan
Hattie A. Talcott and Ethel M. Talcott of Joliet, Illinois
(Note the large patriotic hanging design for Regatta week)

Two hours later they had taken possession of their cottage, unpacked their trunks and settled themselves for the summer.

The children had taken off their shoes and stockings and run down to the lake to paddle around at the water's edge, where it was perfectly safe; Mrs. Jarrod was instructing a maid that Wilder had promptly secured and sent to her, while Jarrod himself-collarless and in his shirt sleeves-had drawn an easy chair out upon the porch and set himself down to think.

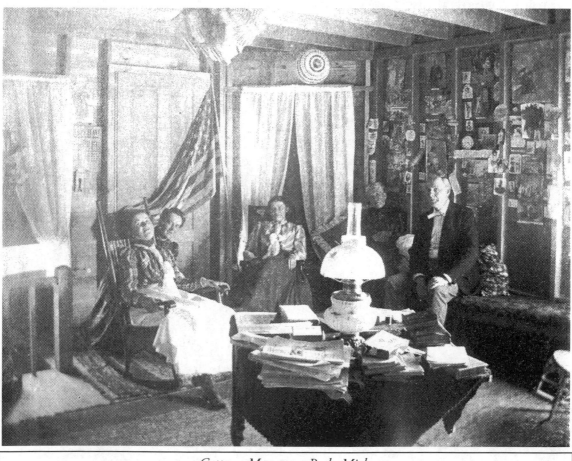

Cottage, Macatawa Park, Mich.

On a tree facing him was a sign that read: "Ask Wilder." These signs he had noticed everywhere at Tamawaca, and as he stared at this one he smiled grimly.

Dressed in her bathing uniform she reclined upon the sands in company with several companions likewise attired and listened eagerly to the comments of two young ladies who had made an important discovery.

"He came this morning, girls," said Betty Lowden, impressively, "and he's just the cutest thing that ever came off from the boat. Such eyes, my dears!—and such lovely fluffy hair—"

"And the air of a real gentleman, girls," broke in Mary Newton; "you could n't mistake him anywhere; and before we passed him he looked at me twice!"

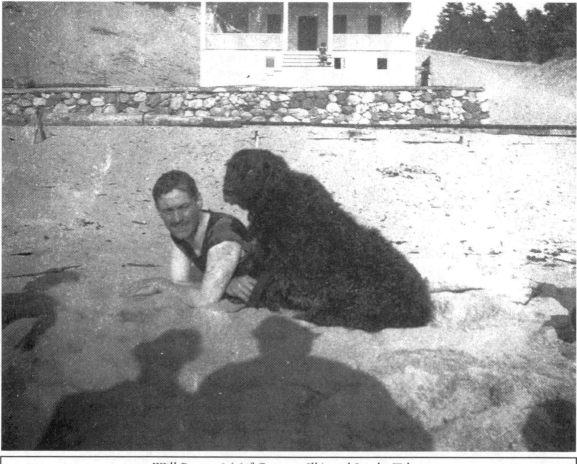

Will Burns, 34 (of Geneseo, Ill.) and Jumbo Talcott

"Seems to me," remarked little Susie, quietly, "that it's a bit of good luck to have any sort of a young man drop down upon us so early in the season. I'm told they're scarce enough at any time in Tamawaca, so I did n't expect to meet a real Charles Augustus for a whole month yet."

"His name is James—James Ingram. Mary and I ran to look at the hotel register, and he's the only man that arrived today."

"Oh, Susie!"

"I'll bet you the sundaes for the crowd, Betty, that I'll be able to introduce him to all of you in half an hour from this second."

"Don't turn around quickly-take your time, Mary. But just let me know if that's James," continued the girl, in a soft voice.

They gave a jump, then, and every one of them stared ruthlessly. They saw a tall young man come down the walk at a swinging stride, glance hungrily at the sparkling waves, and then enter "Wilder's Bathing Establishment," which stood near by, at the water's edge.

"It MUST be him!" gasped the heiress.

"It IS him!" cried Betty, triumphantly. "Is n't he splendid?"

"Say, girls," observed Gladys, "let's take Susie's bet."

"Half an hour, Susie?"

"Half an hour at the most, girls."

"Then it's a go!"

Presently a bather emerged from Wilder's Establishment, walked down to the shore near them, gave a glance of brief interest at the group of girls reclining upon the sands, and straightway plunged into the lake and swam out with bold, vigorous strokes.

Every feminine eye followed him.

"Jim can swim, all right," observed Gladys, admiringly.

Susie nodded.

"I thought he could," she said.

"Now, girls, in we go!"

"What! Into the water?"

"Certainly."

"And get wet?"

"It'll take a week to dry our hair again!"

Susie ignored the protests.

Susie waded in without a quiver, and realizing the importance of the occasion they grew bold and slowly followed her. The heiress waited until the very last, and hesitated even then. But there was "Jim" in the water, and it would n't do to let the other girls get an advantage over her.

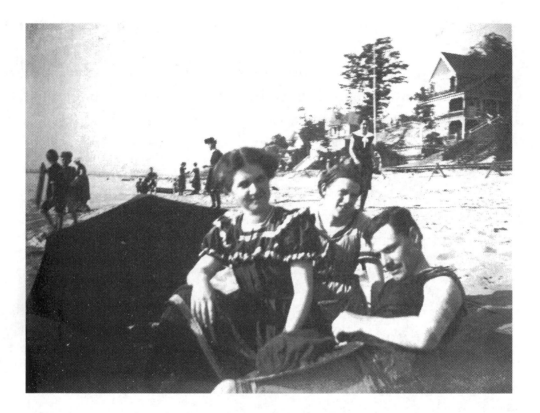

So presently they had all trailed along the gently shelving bottom until the water had reached their waists, and in the case of little Susie, who was in the lead, it came quite up to her chin.

As he drew nearer to the girls Susie whispered:

"Now scream-and scream loud, mind you!"

Instantly the young man rolled off his back and elevated his head, treading water. He saw a girl struggling madly and heard the shrill outcry of her companions. A moment more he was dashing to the rescue.

Mrs. Still, who lived but a few doors from the Jarrods, called upon Mrs. Jarrod the next afternoon, and after welcoming her cordially to Tamawaca and congratulating her upon acquiring pretty Lake View, invited her and Mr. Jarrod to attend a card party at the yacht club that evening.

Jarrod did n't play "five hundred," but when the good-natured Stills called for them soon after dinner he complacently accompanied his wife to the club, which was located half way around the bay and was reached by one of Wilder's ferry-boats after a five minutes ride from the Tamawaca dock.

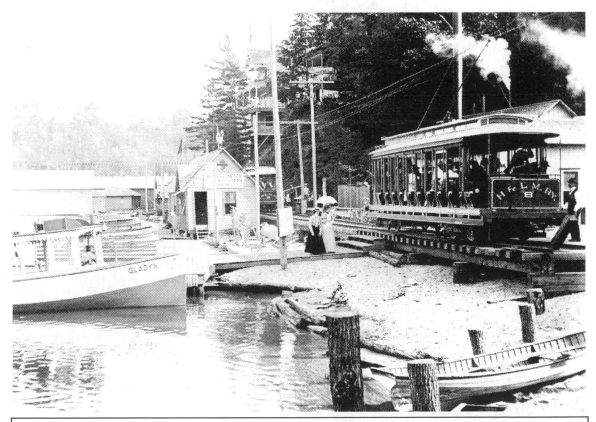

The Ferry "Gladys" to the Macatawa Bay Yacht Club is on the left. The Interurban electric street car was brand new in Macatawa Park just the year before, in July 1898.

It was a pretty building, gay with electric lights. On the ground floor was a reception room filled with sailing trophies, and a big room reached through swinging doors which was devoted to the needs of thirsty men. The upper floor was one large room set with card tables.

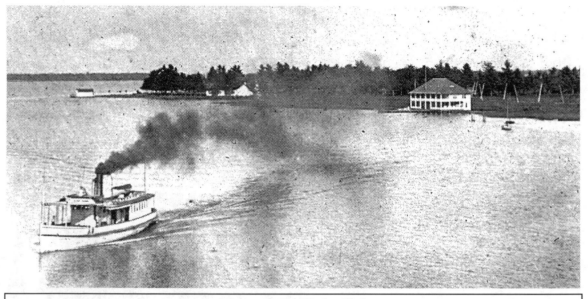

Macatawa Bay Yacht Club

This is the Macatawa Bay Yacht Club's brand new $1500 clubhouse, built that year in 1899, at Jenison Park on the south side of Macatawa Bay—the only one on the east coast of Lake Michigan. It was a two story building built on pilings with wide verandas on both floors and a large dining hall and ball room. The ferry "Gladys" can be seen pulling away on its way back to the dock at Macatawa Park.

Jarrod was ushered by Geo. B. into the thirst room and introduced to a solemn group of three or four men who wore yachting caps and shirts, and had brass buttons sewn on their blue serge coats.

"Howdy," said Berwin, a man with a bald head and serious eyes. "Hear you've bought a cottage, Jarrod. Want to join our Club?"

"I'd like to," the lawyer replied, hesitating; "but I've—"

"Ten dollars, please. That's the price for season membership."

Jarrod paid it.

"But I've got no sail-boat," said he.

"That's all right," observed Stakes, a little fellow with a peppery and pugnacious countenance. "None of the crowd upstairs owns a sail-boat, but they're all club members, just the same. We four-Homperton, Berwin, Diller and myself-own boats, and we're the yacht club in reality. We built this shop on credit, and run it ourselves, but we let the folks upstairs support it by paying ten dollars a year. It pleases 'em to be members of a yacht club, you know, and helps us out financially. Much obliged for your donation."

"Do I have a vote?" asked Jarrod, much amused by the frank explanation.

"Of course; but according to our constitution only men with sail-boats can be officers of the club. So you must vote for us."

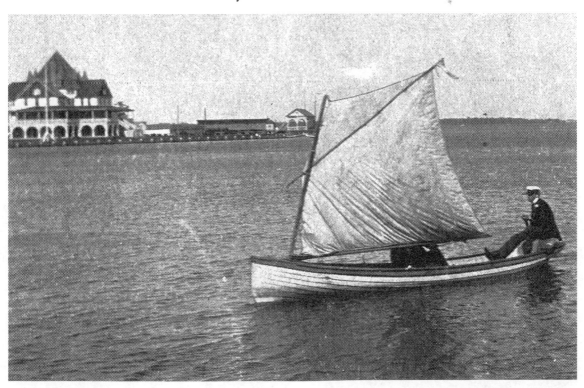

Later in the evening the ferry-boat called for the card players.

Jarrod strolled along the walks for an hour or two, noting carefully the conditions of neglect everywhere apparent. Nature had done wonders for Tamawaca; man had done little but mar nature, if we except the many handsome or cosy cottages that peeped enticingly from their leafy bowers or stood on the hills overlooking the two lakes.

Tamawaca occupies the point between the channel and Tamawaca Pool to the north, and Lake Michigan on the west, where a sloping height is thickly covered with a noble forest that creeps past the dwellings down to the water's edge. In the hills are romantic ravines, flower-strewn vales and vine-covered cliffs. To a lover of nature nothing could be more exquisitely beautiful.

Jarrod tripped and stumbled along the walks. The boards were rotted and falling apart. In places the sand had drifted over and covered the highway completely.

The cottagers would do nothing because they were told the streets and public places were not theirs, and the owners would do nothing because they figured they could get as much out of the cottagers without additional investment.

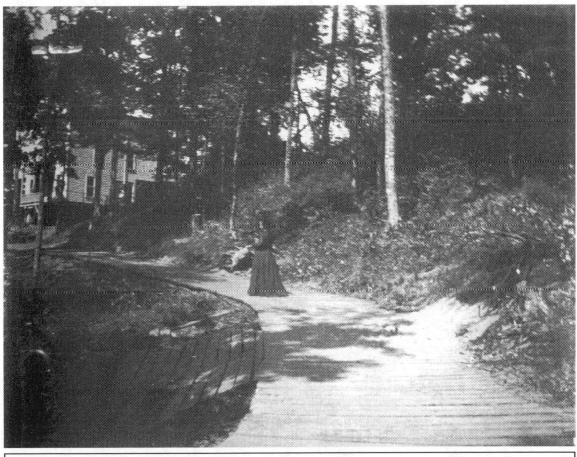

More of the board walks. Note where sand has drifted over on right, as described in "Tamawaca Folks".

A day or two later the lawyer took the electric car to Kochton and read a little Michigan law in the office of a friendly attorney. The result apprised him that he was uncovering nothing more than a huge game of

"bluff," which had been played so long and with such amazing assurance that it had completely cowed its victims.

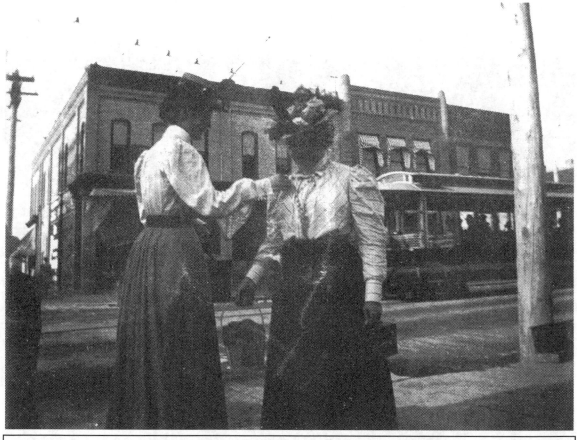

Louise B. Norton, 50 (of Chicago, Ill.), and Hattie Adam
Holland, Mich. (aka 'Kochton' in "Tamawaca Folks". Note the 'electric car' in background.)

Jarrod came home smiling.

"There's nothing like a summer resort for quieting one's nerves," he told his wife.

Susie had faithfully promised her girl friends to bring Jim over to the hotel for the dancing that evening, so she was obliged to invite him to escort her to the dance.

Jim was tremendously fond of dancing, so he accepted with alacrity. When they arrived, Jim promptly began to participate by dancing with Susie. Next he led out Clara the heiress, who in addition to being pretty and graceful was an especially skillful dancer. He danced with Betty next, and with the heiress again; then with Gladys and once more with the heiress. Mary's turn came afterward, and he really ought to have asked Susie once more; but by the time he had taken the heiress out for one final whirl the dancing was over and it was too late.

Clara was glowing and triumphant. She had fairly monopolized the most desirable young man in Tamawaca the whole evening, and it thrilled her with delight to notice how Mary and Gladys frowned at her and shrugged their shapely shoulders, and how saucily Betty stuck up her nose when she found she could not look indifferent. But Susie only smiled cordially at her rival and told Clara she danced as prettily as any girl she had ever met.

Then Jim took them all across to Wilder's for an ice-cream soda-the only entertainment by which it was possible to repay the girls for his delightful evening; and if he shivered a bit when he paid the bill no one could ever have suspected it from his manner.

Instantly he found himself popular with all the girls, for every unattached female at Tamawaca wanted to know the handsome youth. Presently he received so many invitations to go boating and bathing and auto-riding, and for luncheons, picnics, cards and dancing parties, that almost every waking moment of his day was fully occupied. He did not neglect other girls of his acquaintance entirely, but was most often seen in the society of the heiress; so gradually the others came to acknowledge her priority and expected only a modest share of his attention.

But there was only a week of this hero-worship. Then the sky fell.

Katie Glaston came over from Chicago one day, and of course one of her first experiences was to run against Jim and Clara on the board walk.

"Glaston?" said Jim, reminiscently; "any relation to D.B. Glaston?"

"He is my father, sir," said the young lady, and turned her back to speak with Betty.

"What impudence!" she exclaimed, when they had passed out of earshot. "And from Katie Glaston, too! Why, Jim, her father is nothing more than a manager in a department store."

"I know," said Jim, nodding. "He's my chief. I'm in his department at Marshall's Field's. I thought I had told you that I am a mere clerk in a department store."

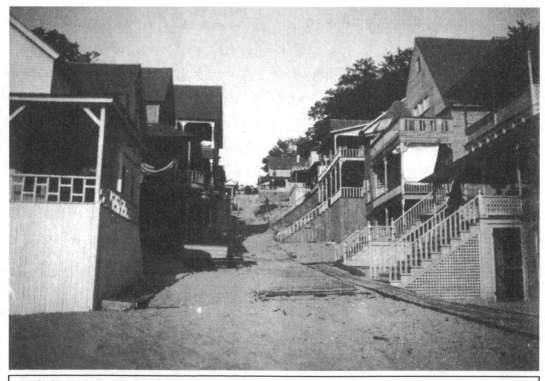

Mishakawa Avenue, Macatawa Park, Mich. (aka 'Mishahaken Avenue' in "Tamawaca Folks")

They turned at once and retraced their steps. An the corner of Mishahaken Avenue they again passed Katie and her group of friends.

Poor Clara's humiliation was so great that she nearly sobbed outright. A clerk! A mere clerk in Marshall Field's. And she had been devoting herself to the fellow for a whole week!

The discarded youth lightly retraced his steps to the hotel, whistling reflectively as he went—which was ample proof that he did not realize how serious was the wicked imposition he had practiced.

Then, one afternoon as he passed the Carleton cottage, Susie Smith ran out and seized him, urging him so cordially and unaffectedly to come in for afternoon tea that he could not well refuse.

Tamawaca society is made up of many little cliques, as indeed is society everywhere, certain people being attracted to one another through congeniality or former association. So it happened that the Carleton clique was one somewhat exclusive and removed from those to which Jim had formerly been introduced, and he met with no humiliating slights. Susie treated him exactly as she had before Katie Glaston's unfortunate arrival, and made him grateful by neither overdoing her cordiality nor referring to his humble condition in life. It was a friendly atmosphere, and put him entirely at ease.

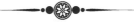

It did not take Jarrod long to decide that there were no grounds for Wilder's claim that the streets and parks at Tamawaca were in his control. On the contrary they belonged entirely to the cottage and lot owners, neither Easton nor Wilder having any more legal rights thereto than the most insignificant cottager.

Once day, during his rambles, Jarrod came upon a fine cottage perched high on the hill overlooking the bay. One the porch was seated an old gentleman whom the lawyer recognized as Colonel Kerry.

"Come up and sit down," called the colonel, hospitably.

So Jarrod sat down to rest.

"I'm glad to learn you're a new resident," said Kerry. "You have bought Lake View, I understand."

"Yes," acknowledged Jarrod. "There was nothing to rent, so I had to buy a cottage or go elsewhere."

The colonel smiled.

"Plenty of places to rent," he observed.

"Wilder said not."

"He may have said so. See that cottage across the way? It's a very nice place; belongs to Grant of St. Louis; has been for rent all this spring."

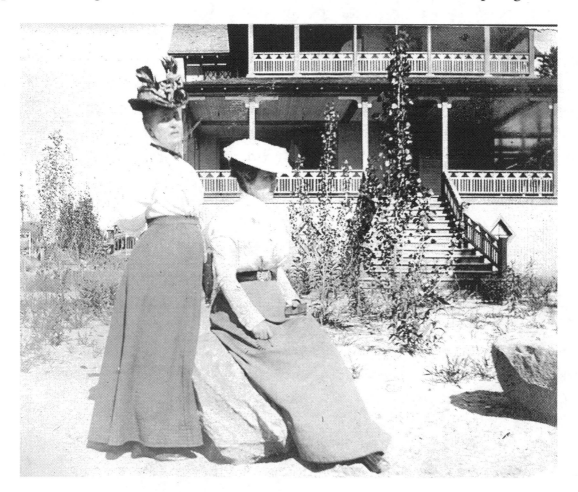

"Oh. Wilder said it was rented. I tried to get it, you know."

Again the colonel smiled, and his smile was the sardonic kind that is sometimes exasperating.

"Wilder wanted to sell Lake View," he exclaimed; "but he's been holding the place for seventeen hundred and fifty, which is more than it's worth. Perhaps you whittled the price down to where it belonged."

Jarrod did not reply. He felt rather uncomfortable under the colonel's shrewd glance.

"Tamawaca's a beautiful place," said Jarrod, glancing over the wonderful scene spread out before him-a scene with few rivals in America. Framed by the foliage of the near-by trees, Tamawaca Pool lay a hundred feet below him, its silver bosom dotted here and there with sailing craft, launches, or pudgy ferry-boats speeding on their way, while the opposite shore was lined with pretty cottages nestled in shady groves.

But your public affairs are in a terrible condition, Colonel Kerry."

"I agree with you."

"Why don't the people rise up and demand their rights?" enquired Jarrod, curiously.

"Simply because they're here for rest and enjoyment, and not to get mixed up in law-suits and contentions."

Once a year the cottagers meet and talk things over, and rail at their oppressors and become very indignant. Then they go home with the idea they've performed their full duty. Those meetings are good fun, Mr. Jarrod. Wilder always attends them and welcomes every cottager as cordially as if he were giving a party. Then he sits in a front seat and laughs heartily at the rabid attacks upon himself and his partner. The next annual meeting is tomorrow night. I advise you to go.

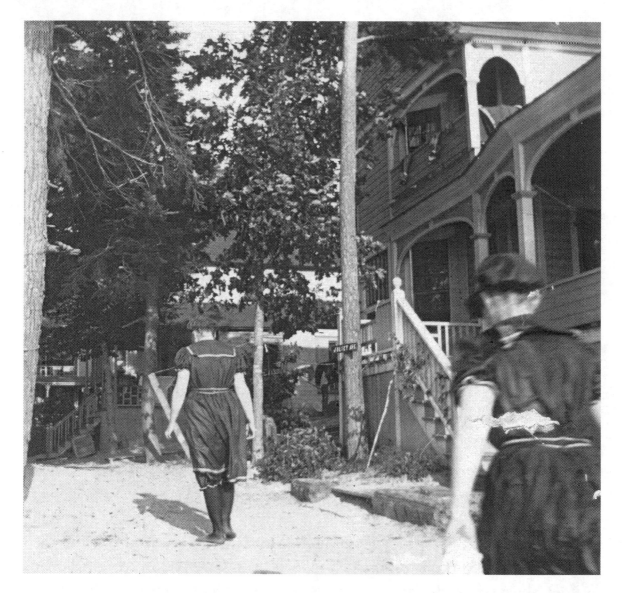

Saturday evening Jarrod attended the meeting. It was held in a big shedlike structure in the woods called the "Auditorium," where divine services were held on Sundays. All Tamawaca was there, for the men took their wives to enjoy the "fun." It was the only occasion during the whole year when the cottagers got together, and here they were accustomed to frankly air their grievances and then go home and forget them.

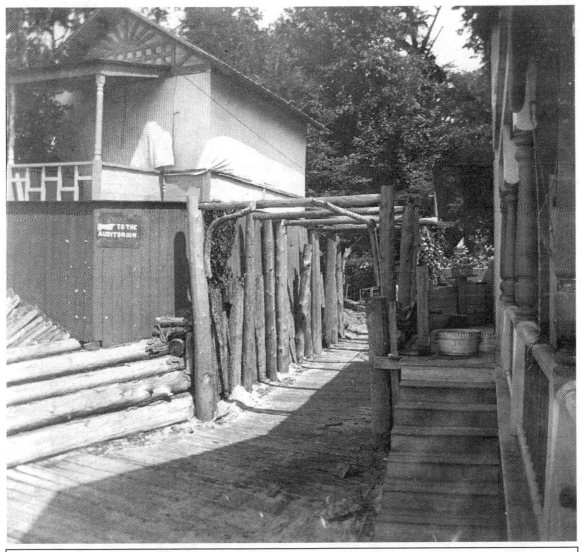

Note the sign: "TO THE AUDITORIUM". *Macatawa Park, Mich.*

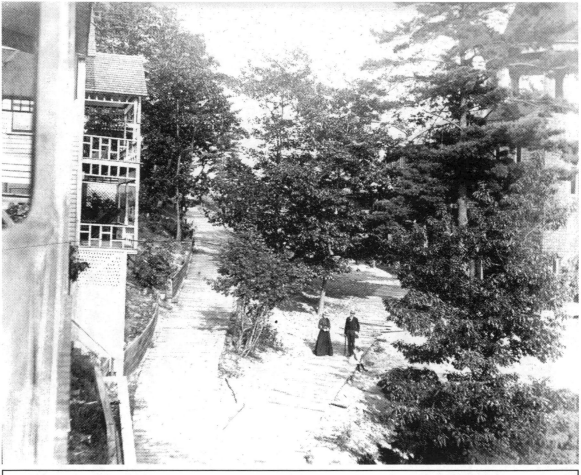

Board walks leading to the Auditorium building (on the right).

"I am a newcomer here," said Jarrod, "and have recently bought the cottage known as 'Lake View.' With that property I acquired an equity in all the parks and highways of Tamawaca; but I find that some one has usurped portions of those parks and highways and erected cottages and other buildings upon them. Those buildings must be removed, and the public lands be restored to the public.

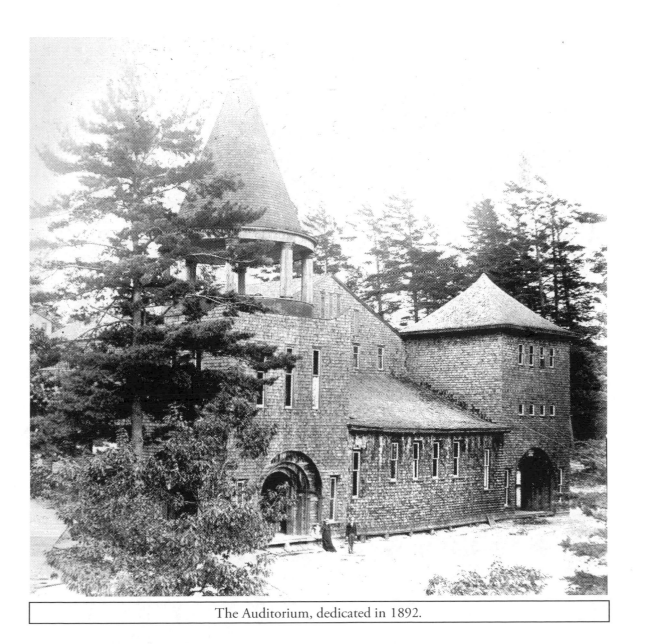

The Auditorium, dedicated in 1892.

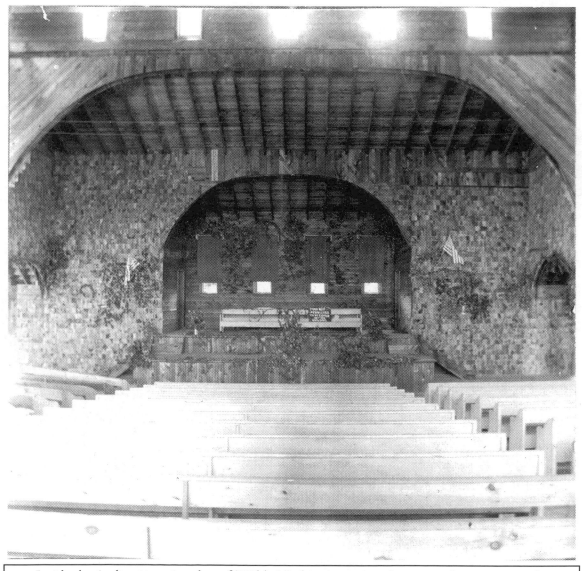

Inside the Auditorium. Another of 'Wilder's" ubiquitous signs is seen on the stage, it reads:
"FOOD NOT PERMITTED TO BE EATEN IN THIS BUILDING."

Then he put the motion to vote, and the people shouted "Aye!" with an enthusiasm the old Auditorium had never heard before.

This is an extremely rare view of the short-lived canvas covered structure known as the Pavilion, built over the waters of Lake Michigan in 1895. In this photo the Pavilion is already missing the canvas roof and appears to be in disrepair. Wilder himself (aka Fred K. Colby in real-life) served refreshments from the building on the right. Note the original Holland Lighthouse in the distance.

"The girls told me yesterday," Susie said to Jim, "that Katie had written her father and asked him to discharge you, because you had been impudent enough to become acquainted with the exclusive young ladies of Tamawaca under false pretenses."

"But I did n't, Susie! I met them through your accident, and they never asked me how I earned a living."

"I know; but they forget that. They say you imposed upon them by assuming that you are a gentleman."

Jim laughed merrily.

"Where do you draw the line, Susie, between a gentleman and—and—what's the other thing?—an undesirable acquaintance?"

"Perhaps so. I don't draw the line, myself, so you must ask the girls to explain. Perhaps, now that you've become the private secretary of a famous lawyer, you will be cultivated instead of being snubbed. But I'm not sure of that."

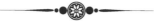

When "Regatta Week" arrived-the week of the Yacht Club boat races, when the four yachtsmen competed for the prizes that were donated by the liberal merchants of Kochton and Grand Rapids, and divided the spoils amicably-during that week Jim helped to get up the annual "Venetian Evening," the one really famous attraction of the year.

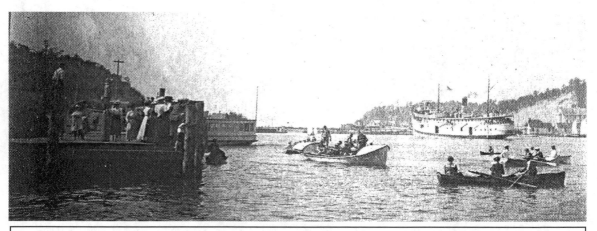

<u>1899 Regatta of the Macatawa Bay Yacht Club, Macatawa Bay, Mich.</u>

The annual regatta of the Macatawa Bay Yacht Club began the first week of August 1899, and it attracted what the Chicago Daily Tribune called a large crowd of Chicagoans. The cottages of Macatawa Park were filled to overflowing and at the Macatawa Hotel many were obliged to sleep on cots, but everyone had a good time. Many bathed, yachted, fished, picnicked, and attended trolley parties. Many yachts came in from Chicago. A crowd can be seen gathered on the dock to the left to watch the festivities.

The Yacht Club, the hotels and Iroquois Bay and Tamawaca and all the buildings facing the bay were elaborately decorated with bunting and lanterns, while the sail-boats anchored upon the mirror-like surface of the water displayed a like splendor. Bands played on the ferry-boats, bonfires on the neighboring heights glared and twinkled, many launches brilliant with colored lights moved slowly over the bay, while rockets and roman candles sent their spluttering displays into the dim sky overhead. All the world was there to see the sight and the popcorn and peanut men reaped a harvest.

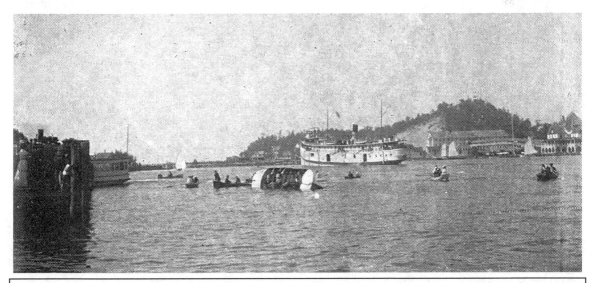

1899 Regatta of the Macatawa Bay Yacht Club, Macatawa Bay, Mich.

The fourth cup race of the Macatawa Bay Yacht Club regatta took place on August 26, 1899. Macatawa Park and Ottawa Beach were both crowded with Chicago people who came over to see the race. Captain Pardee of the steamer Soo City (seen in the center of this photograph) settled a dispute among the yachtsmen that week by measuring the racing course with a standard taffrail log that was borrowed from Commander Wilson of the Chicago Hydrographic office. It was found to be five and a half nautical miles, and Captain Pardee received a vote of thanks from the Macatawa Bay Yacht Club for his trouble. Class D first prize was a yacht cap, second prize was a boat hook. Class C first prize was marine glasses, second prize was a hand lantern. Class B first prize was a folding anchor, second prize was a ring buoy.

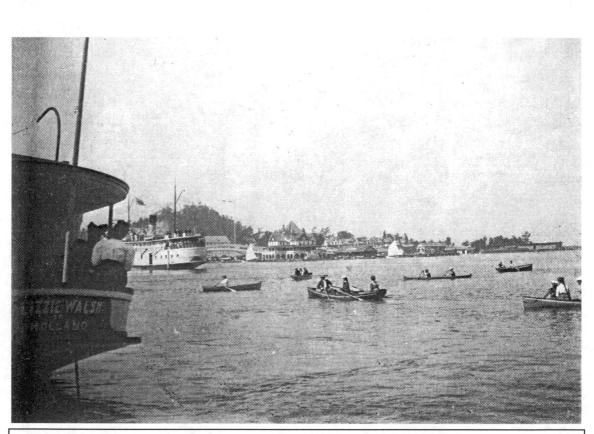

<u>1899 Regatta of the Macatawa Bay Yacht Club, Macatawa Bay, Mich.</u>

The Lizzie Walsh was a 37-ton propeller boat built in 1884 for Jay McCluer by the Robertson & Co. Shipyard/Grand Haven Ship Building Co. This elegant little steamer, also seen earlier in this book in photos of the Boat Livery area, was privately owned by two local Holland residents and began service on Black Lake (Macatawa Bay) in 1888. The Lizzie Walsh ran out of Holland and was very busy making daily ferry trips from Holland to all of the resorts, and as a general pleasure yacht.

Life Saving Station, Macatawa Park, MI Opened in August 1886.

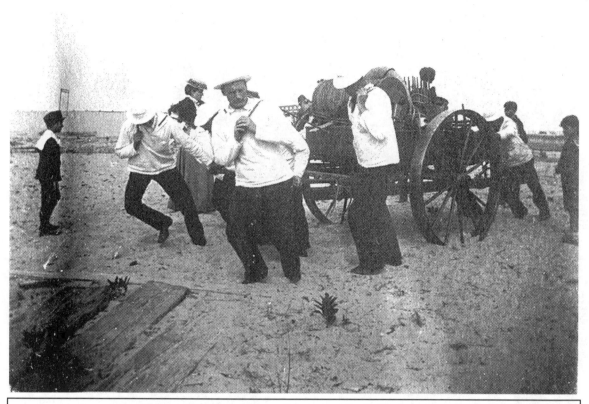

Life Saving Crew, Macatawa Park, Mich

Newspaper reports stated that the United States Life Saving Station had been working overtime during the Macatawa Bay Yacht Club's regatta rescuing capsized yachts-men and pulling off some of the finkeelers that didn't know the channel. This photo, of a breeches buoy drill as it was sometime called, was practiced by the Keeper and all surfmen at all stations every Thursday at 2pm as per the U.S. Lifesaving Service manual. Crews that couldn't perform the drill in adequate time faced dismissal from the service. It was the crew's responsibility to maintain each piece of equipment in ship-shape as the safety of the crew and the success of the rescues depended upon it. The beach cart, seen in this photo, was pulled by two surfmen, pushed by two and steered by two. The beach cart rode on two wheels and fully loaded could weigh nearly a ton. It was crucial that the cart be loaded in a specific order where the first item loaded was the last item unloaded.

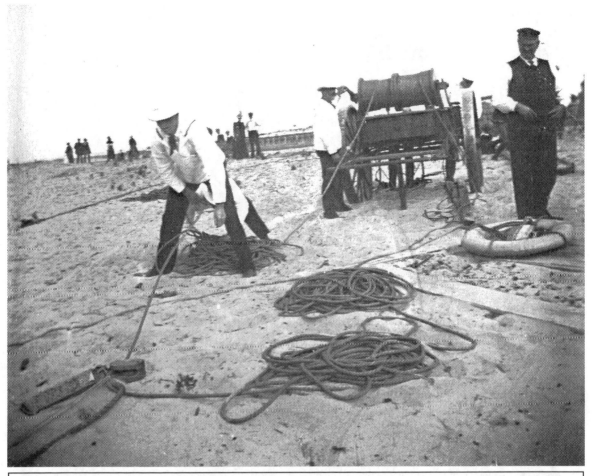

Life Saving Crew, Macatawa Park, Mich

The long wooden tally board (lower left corner of photo, attached to the traveling block) was used to deliver instructions to the vessel in peril. The whip consisted of two whip reels mounted on the beach cart, the whip line, and the whip block. Once the shot is fired across the wreck or wreck pole, the shore-side end of the shot line was tied to the tail block. Once the line had been secured to the vessel, the whip was used to haul items such as the hawser, breeches buoy and sometimes the life-cart back and forth between the beach and the wreck. This operated in the same manner as an old-fashioned clothes line with pulleys, and was operated by surfmen pulling on either the windward or leeward half of the whip from shore. The hawser line carried the traveling block and attached breeches buoy (right edge of photo, on ground) back and forth from the vessel by means of the whip. The breeches buoy was essentially a life ring sewn into a pair of short pants, used to transport a wreck victim from the ship to the beach.

Life Saving Crew, Macatawa Park, Mich

The fall was a block and tackle pulling device used to place tension on the hawser. The fall consisted of inner and outer blocks, and had a ratio of 4:1 giving five surfmen the pulling strength of twenty. The outer block was painted blue to indicate that it was to face seaward and the inner block was painted white to indicate that it was to face shoreward and was attached to the sand anchor pendant. The sand anchor was used to secure the shore-side of the fall to the beach. A narrow trench was dug in the fashion of a cross to a depth of approximately 2 1/2 feet, and the sand anchor was placed in it and buried.

It has been seriously asserted that Venice in its palmist days has never been able to compete with Tamawaca on "Venetian Evening."

During the delightful August weather social functions at the resort reached their acme of enjoyment and followed one another as thickly as the fleeting hours would permit. In some circles these affairs were conducted with much solemn propriety; but many folds who suffered under the imperious exactions of "good form" during the rest of the year revolted from its tyranny while on their summer vacations, and loved to be

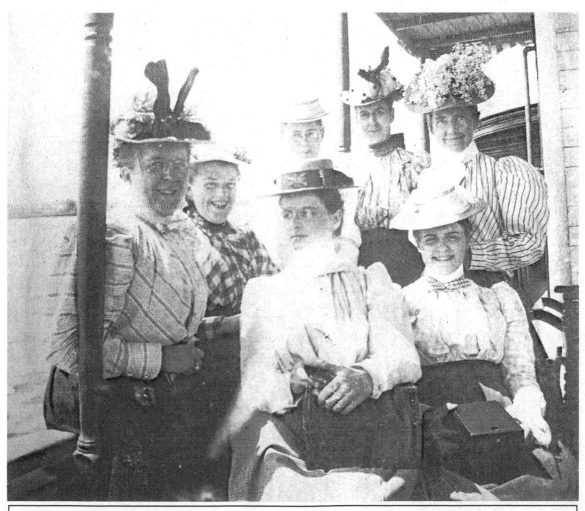

(Note the Kodak No. 2 box camera in lap of the woman seated on right.)

merry and informal. They were gathered from many cities of the South, East, North and West, and here thrown together in a motley throng whose antecedents and established social positions at home it would be both difficult and useless to determine. So certain congenial circles were formed with the prime object of "having a good time," and they undoubtedly succeeded in their aim.

Jim, who before he quarreled with his father had been accustomed to mingle with the 400 of old St. Louis, was greatly amused at some of these entertainments, many of which he attended with demure little Susie.

Rivers, a jolly fellow who owned a lake front cottage-one of the titles to distinction at Tamawaca-organized a "surprise party" on George B. Still (another lake-fronter) one evening. A band of some twenty people assembled at the cottage of a neighbor, all carrying caskets laden with frosted bricks in place of cake, beer bottles filled with clear spring water but still bearing Budweiser labels, mud-pies with nicely browned crusts, turnips fried to resemble Saratoga chips and other preposterous donations of a similar character.

Then they stole silently to George's cottage, and when he opened the door in answer to their timid knock burst into a sudden flood of merriment that never subsided until after midnight.

Then they jumped up and trooped into an adjoining room, where the frosted bricks and mud pies had been spread for a banquet; and although George B. accepted his donations with good humor the guests began to wonder if the joke was not on themselves, after all, since their jolly exertions had created a demand in their interiors for real food.

"This way, please!" called Mrs. Still, cheerily, and threw open another door, disclosing an enticing array of provender that caused a stampede in that direction.

"How on earth did you happen to have all this on hand?" Susie enquired of Mrs. Still, as she and Jim squeezed themselves into a corner.

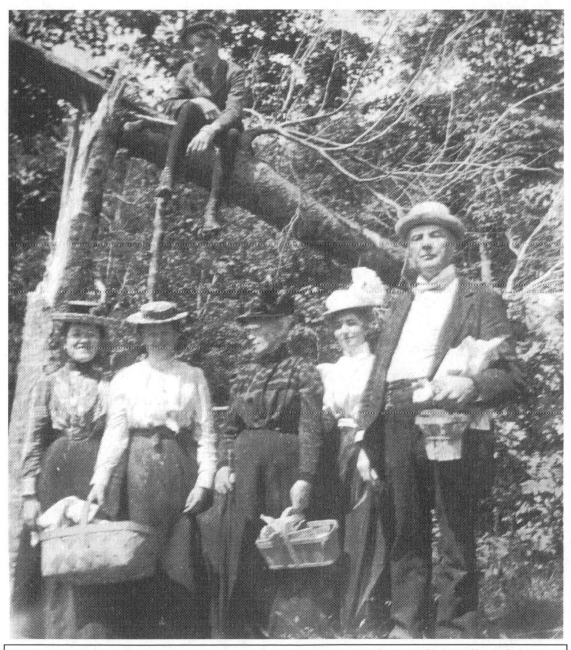

Participating in the "Venetian Evening" festivities are *Persis Chapin (of Joliet, Ill.), Ethel M. Talcott (of Joliet, Ill.), P.F. Clayes, Ella Browne (maiden name Chapin), Rev. Edward Browne (both of Chicago, Ill.), and Raymond Talcott (of Joliet, Ill., in tree)*

"I had an intuition there'd be a lot of hungry folks here tonight, so we've been busy all day getting ready for them."

After the supper, which consumed two hours in being consumed, Mr. Idowno once more claimed he must be going; but the guests rose up and loudly demanded the prizes they had won at cards. From the size of the hubbub it appeared that nearly every one present was entitled to a prize.

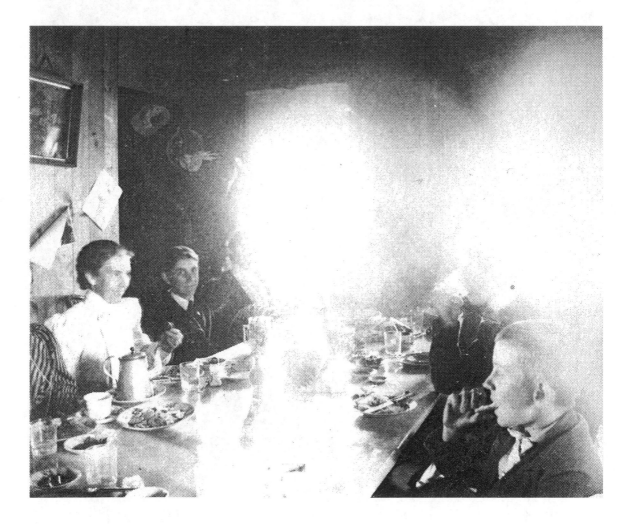

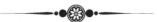

"Jim," said Colonel Kerry, meeting the young man at the post-office, "that cottage of Grant's, up near mine, has been rented at last. The parties took possession today."

"Who got it, Colonel?"

"One of the big millionaires of St. Louis, they say; and he's arrived with his wife and daughters and a whole gang of servants.

"You—you did n't hear the name, Colonel?"

"Why, yes; it's Everton."

There was considerable excitement in quite Tamawaca over the advent of the Evertons; for while the resort boasted several families of great wealth, none was so marvelously rich or of such conspicuous note as the well known patent medicine man who had won mountains of gold by the sale of his remedies.

When Jim went to Susie with a hanging head and told her his father had come to the very place where he had himself taken refuge, the girl counseled with him seriously, and advised him not to run away but rather to meet his family frankly and if possible resume friendly relations with them.

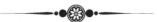

"Mr. Jarrod," said Jim when he went to work next morning, "father's here. Does he know I'm here?" he asked, hesitatingly.

"I told him. He did n't know it until then. Your mother and Nellie and May are all delighted and eager to see you."

"And father?"

"He did not express himself as glad or sorry. You've offended him deeply, Jim."

"Dad has a dreadful temper, and when he gets on his high horse all I can do is to jaw back."

"He's sick, Jim, and his pain makes him crabbed. Why not try to bear with him, and be friendly?"

"That's what Susie says. Perhaps I really ought to go up to the cottage and call."

Before he could knock the door flew open and he was in his mother's arms. The poor lady was sobbing with joy, and led her errant son into the room where his father sat propped with cushions in an easy chair.

"Here's Jim!" she said, trembling with uncertainty and a well founded fear of the interview to follow.

Mr. Everton looked at his boy and nodded. "They tell me you're working. A lawyer's clerk."

"I'm Mr. Jarrod's private secretary, sir. I've discovered that I can earn my own living," said the boy, flushing.

"That is n't the point. I reared you with the expectation that you would be of some use to me when I grew old and feeble. That time has arrived. I need you to help look after the business. Look here: do you owe nothing to me?"

Jim examined the pattern on the rug.

"Just as much as I owe myself, sir. Surely not more."

"Then pay your obligation to me first, and you can do as you please afterward."

"All right. That's fair."

"Very well. You shall be my assistant and have an interest in the business. I'll allow you ten thousand a year."

"Good!" said Jim, brightening suddenly. "Then I can get married."

"Oh, Jim!" cried his mother.

"To whom, sir?" asked his father.

"Why, to Susie. Perhaps you have n't heard of her. She's a girl I met at Tamawaca."

"What's her other name?"

"Smith. Susie Smith," dwelling on it lovingly.

"Smith! Well, who is she?"

"The sweetest girl in all the world, sir."

"Bah! Who are her people? Where does she come from?"

"I don't know."

"Nonsense."

"Susie lives in New York, I think, or some Eastern city. Her mother is dead but her father is still on deck—I'm positive of that, for she often speaks of him."

"What does he do?"

"Can't imagine, I'm sure."

"Jim, you're a fool—a doddering imbecile! You'll have to give up that girl for good and all," he roared. "Susie Smith! Some cheap stenographer or a paid companion to Mrs. Carleton, I suppose. Some designing hussy who thinks you'll have money, and wants to get her clutches on it. Susie Smith! For heaven's sake, Jim, why can't you have a little sense?"

"I hope you'll soon get better, sir," he remarked. "I shall be in Tamawaca for some weeks yet, and if I can be of any help in any way, let me know. Good bye, mother."

As he turned to go the door burst open and Nellie and May dashed in and threw themselves upon their brother with glad cries and smothering kisses.

"We've heard all about it, in the town," said one. "Oh, Jim, you lucky boy! She's an old friend of ours. We knew her at Wellesley, and we've just called upon her and kissed her and hugged her for old times' sake. Father, it's Susie Smith!"

"Smith!" with a snort of contempt.

"The only, only child of the great Agamemnon Smith, the richest Standard Oil magnate after Rockefeller himself!"

Jim fell into a chair and stared at his father. His father stared at him.

"To think that Susie Smith will be our sister!" cried Nell, clasping her hands ecstatically.

And—and—Jim can change that name of Smith, you know," faltered poor Mrs. Everton, glancing at her husband nervously.

The invalid roused himself and looked up with a smile.

"So he can," he observed, drily. "Hang up your hat, Jim, and let's talk it over."

Jim hung up his hat.

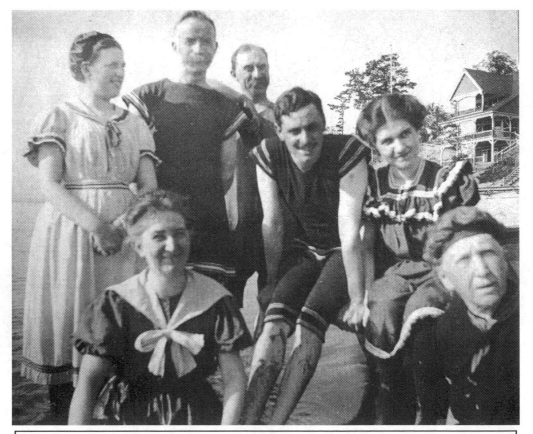

(top) Ethel M. Talcott, Rev. Edward Browne, Charles H. Talcott, Will Burns, and Persis Chapin; (bottom row) Ella Browne (maiden name Chapin) and Parthena F. Clayes, 67 (Hattie's mother, widowed, of Joliet, Ill.)

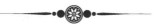

The "New Tamawaca" began to arouse the interest of the cottagers, who threw themselves heart and soul into its regeneration. Things were

done for the first time in the history of the place, and done with a will and enthusiasm that accomplished wonders in a brief period. Miles of cement walks were laid through the woods, and a broad thoroughfare now extends the length of the lake front, where once it was dangerous to travel on foot.

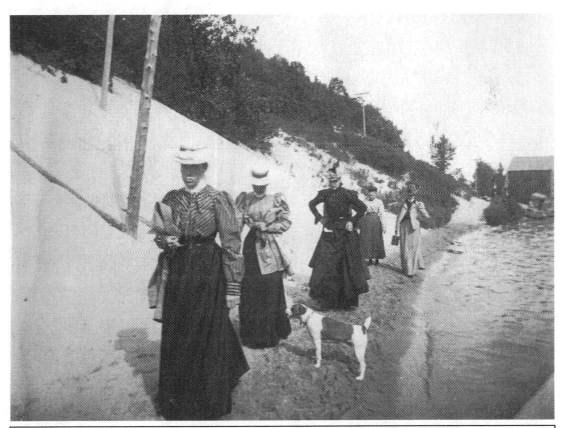

Walking on beach, Macatawa Park, Mich.
Edna Keith, 29 (of Joliet, Ill.), Hattie Adam, Mrs. J. C. Norton, Ethel M. Talcott (of Joliet, Ill.), and Louise B. Norton, 50 (of Chicago, Ill.)

Because of all this, and the era of prosperity that has dawned upon it, Tamawaca is growing steadily and many pretty cottages are springing up on the vacant lots.

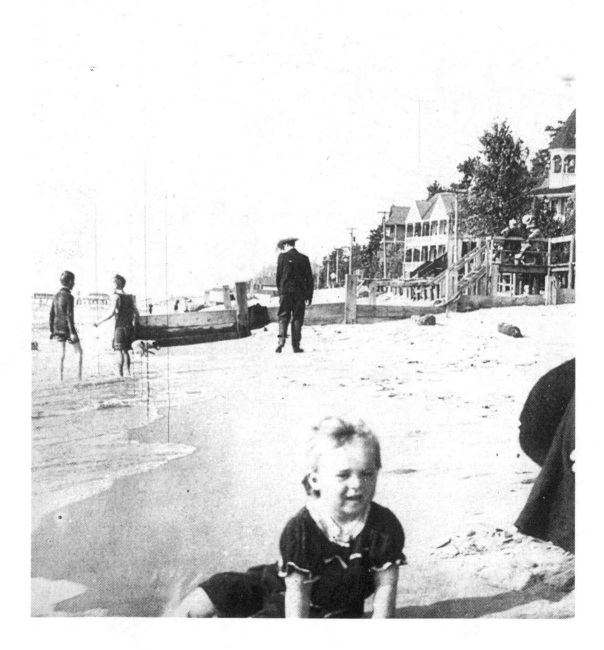

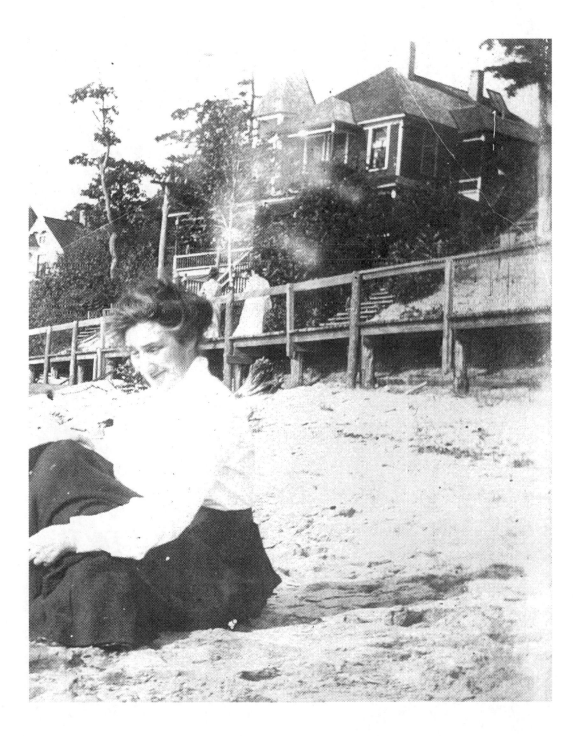

EPILOGUE

L. Frank Baum

Flush with cash from his first literary hit "Father Goose," and after his first visit to Macatawa in 1899, L. Frank Baum rented a cottage in Macatawa for the entire next summer of 1900. He liked Macatawa so much that by the following summer of 1901 he bought the cottage, which he nicknamed "The Sign of the Goose" in honor of his book. "The Sign of the Goose" was just a few houses down the hill from where our photographer Hattie Talcott and her family stayed in the Summer of 1899 (as well as several summers after that.) Did you see a familiar couple in the photo on the previous page (taken on Sept. 4, 1903)? It's the same familiar spot on the beach where both Hattie AND the Baums frolicked year after year. HINT: The cottage in the upper right corner of that image is L. Frank Baum's "The Sign of the Goose"!

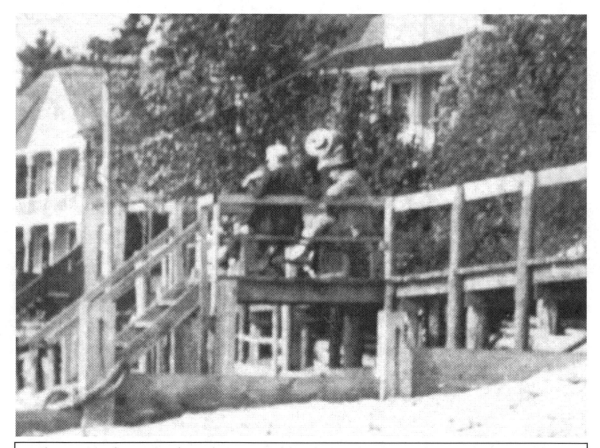

Enlargement of previous photo showing Maud and L.Frank Baum soaking in the Macatawa Park environment directly in front of their cottage (dated Sept. 4, 1903).

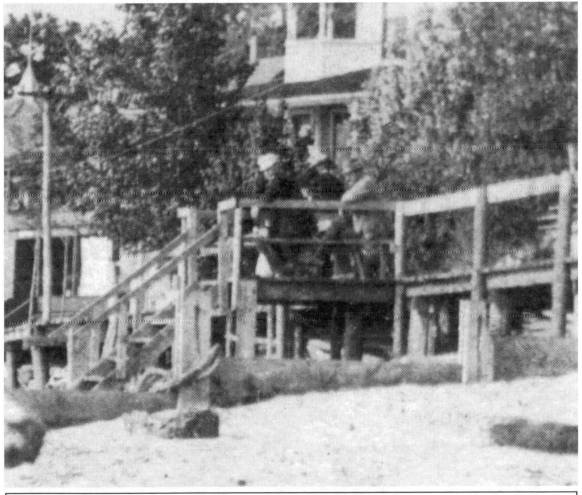

Here's another image of Maud and L. Frank Baum immersing themselves in Macatawa Park from that same alcove on the board walk, this time on Sept. 3, 1903.

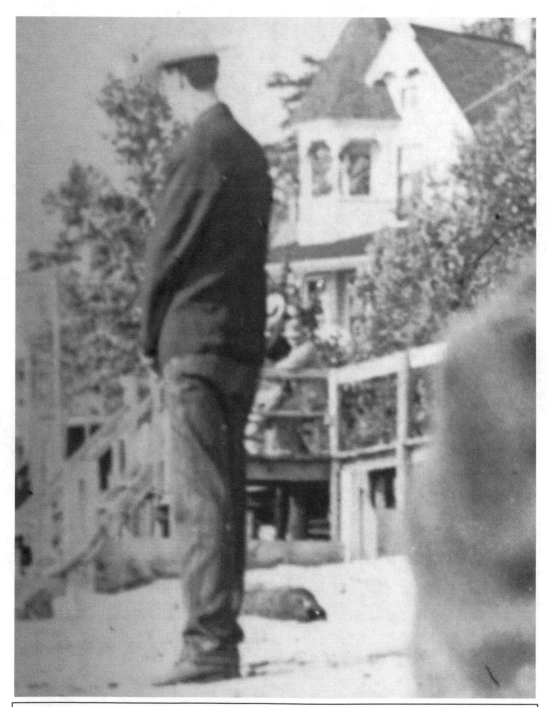

In fact, Maud and L. Frank Baum are seen sitting in that alcove in every photo in Hattie's album taken in that location—even in this photo dated the year before in 1902!

Then there is this fellow often seen walking on the beach in front of "The Sign of the Goose", maybe walking the dog that's playing in the surf, maybe watching over the two boys. He is in at least two of the photos when Maud and L. Frank Baum are sitting in the alcove—one in 1902 and another in 1903. Might this be one (or three) of the four Baum sons?

The book following L. Frank Baum's first visit to Macatawa, "The Wonderful Wizard of Oz," published to instant success in 1900, at $1.50 a copy. In 1903 it would be adapted as a musical for a long, critically acclaimed run on Broadway. Eventually, with the draw of fame, L. Frank Baum moved out of Chicago (and thus out of the reaches of Macatawa) in 1910 (to Hollywood, of course!) Though born with a bad heart, L. Frank Baum lived until 1919, writing one book a year to satisfy his large fan base.

The Board Walks

Thanks to the efforts of Jarrod (Basil P. Finley), the board walks were greatly improved by 1906. Compare the "before" photo of the board walk up Mishawaka Avenue on page 50 with the following photo of the same view up Mishawaka Avenue from a postcard circa 1907.

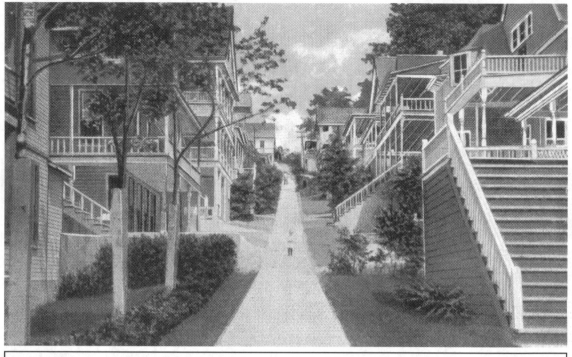

Mishawaka Avenue, Macatawa Park, Mich—c1907 ("after")

The Macatawa Hotel

The Hotel Macatawa continued operations until 1956, when it was torn down for business reasons to make room for the Point West Restaurant.

The Ottawa Beach Hotel

The Hotel Ottawa at Ottawa Beach (below) was significantly enlarged just two years after this photo, in 1901. Ultimately though, the Ottawa Beach Hotel was destroyed by fire in 1923, caused by defective wiring. It was never rebuilt.

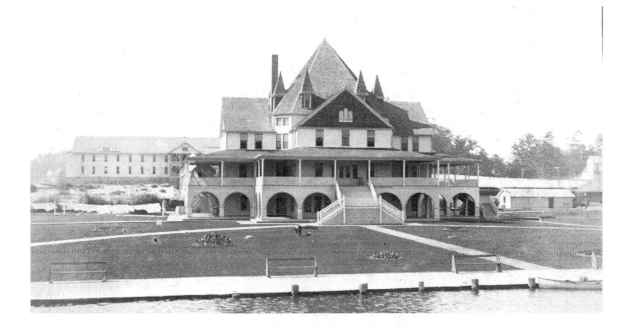

The Macatawa Bay Yacht Club

The Macatawa Bay Yacht Club, founded just 4 years earlier operating out of a boat house in 1895, continues today in a different clubhouse built on a lot adjacent their original.

The Interurban Electric Cars

Just a few short months after these photos were taken, in January 1900, the barns in which the Interurban cars were stored suffered a major fire, destroying all 10 passenger cars. The cars were quickly replaced and resumed service that April, though the Interurban ultimately went bankrupt in 1926.

The Auditorium

In May 1910 Macatawa Park decided to rebuild the aging Auditorium, at a cost of $1140, and a cement sidewalk was added to its north and south entrances.

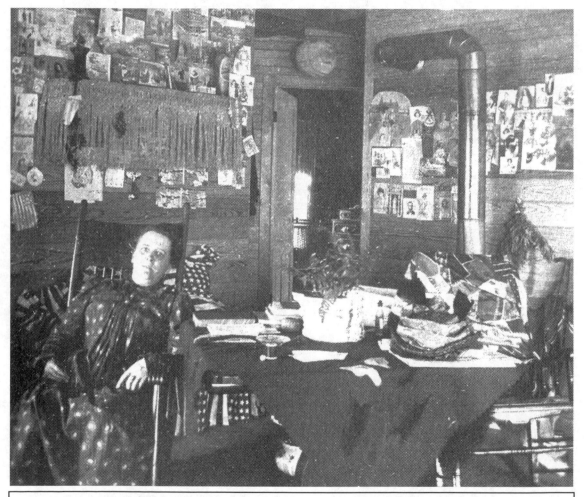

Uneeda Rest Cottage, Macatawa Park, Mich. (Note heater on right)

Macatawa Cottages

Four fires in the 1920s destroyed most of Macatawa Park as L. Frank Baum knew it. The fire of 1922 in particular destroyed everything north of Interlake Walk. That fire started in the Ellis cottage, which was the second house north of Interlake Walk, and was caused by a failed kerosene water heater. (Most cottages at the time not only heated their water with kerosene, but also cooked with it.) With a strong southwest wind blowing that day, in time all houses north of the Ellis cottage burned to the ground.

But it was the fire on the night of April 14, 1927, the third great fire at Macatawa, that was considered to be the most disastrous fire that ever visited Macatawa Park. That fire destroyed 35 cottages, including L. Frank Baum's cottage, "The Sign of the Goose," as well as the *Uneeda Rest Cottage* and the *Ledeboer Cottage* shown in multiple photos. It was said at the time that even more disastrous than the loss of the cottages was the loss of the beautiful natural woods surrounding those cottages.

In the book "Macatawa Park: A Chronicle", Donald L. van Reken wrote that the fire started shortly after 9:00 in the *Lind Dale* cottage. From this cottage the fire jumped to the *Nahee* cottage on the Lake Michigan front, one of the first cottages built at Macatawa, which soon burst into flames. In a comparatively short time the *Nahee* cottage was a mass of flames and within a few minutes "The Sign of the Goose" took fire. From this large blaze the cottages nearby took fire and from then on the fire swept eastward, eating its way against the wind, flames leaping over the hill, engulfing the *Uneeda Rest Cottage* and the *Ledeboer* cottage, into the valleys, until a path was swept clean of forests and buildings from the Lake Michigan front nearly to Macatawa Bay on the east.

At shortly after 9:00pm Chief Blom of the Holland Fire Department received a telephone call from Macatawa asking for help. The report was that the Coast Guard station at Macatawa was ablaze. Mr. Blom

immediately sent a company of firemen and one of the large pumpers to Macatawa, but there was no easy way to get to the fire through the heavy drifts of sand because of inadequate highways to the Lake Michigan front. With a passable road near Lake Michigan the fire could perhaps have been confined to the *Lind Dale* cottage because the fire department was there in ample time to have checked the blaze.

Instead Chief Blom and his firemen were compelled to stretch a line of hose for a third of a mile over hills, down valleys, through underbrush and many other obstacles before the blaze could be reached, thus loosing a great deal of time and half of otherwise available water pressure with which to fight the fire.

The flames were stopped past the *Uneeda Rest Cottage* at Griswold Walk. The next street to the north was Mishawaka Avenue, where the cottages practically touch they are built so closely together (see photo of Mishawaka Avenue earlier in book). If the fire had reached Mishawaka Avenue it would have meant the destruction of everything, so the pumper was transferred to the foot of Griswold Avenue, which was a wise move as the fire had been checked at the other end by Lake Michigan. This prevented the fire from going farther east and then around the hill to the north, and also prevented the destruction of the cottages built in the valley near what was known in 1899 as the "Golden Gate Walk."

A few days after the fire, two men were arrested and then questioned in Grand Rapids about the fire. When the investigation was completed it was found that one of the men had set the fire in the *Lind Dale* cottage by placing a wick on the ironing board in the cottage and placing bedding and mattresses soaked with kerosene nearby. The fire started from the slow burning wick. By the time the fire started the man was already home in Grand Rapids. Both of the men were convicted of arson, but the instigator of the whole affair, a former property owner at Macatawa, was never convicted of the crime.

Many owners didn't expect to rebuild, citing the destruction of the environment including the trees and shrubbery. They also cited the fire hazard at Macatawa and costs almost prohibiting the rebuilding of a new cottage.

The April 1927 fire that destroyed "The Sign of the Goose" was so great that it was said that were it not for the Holland firemen and the big Holland pumper, the fire would have engulfed all of Macatawa Park, taking the Hotel Macatawa and all.

What little was left of L. Frank Baum's "The Sign of the Goose" after the fire eventually washed into Lake Michigan.

The victory gained on the fire which destroyed L. Frank Baum's cottage was short lived as just 2 months later, on June 16, 1927, Macatawa's fourth major fire destroyed all remaining cottages on Mishawaka Avenue, Nahant Trail and on Griswold Street, leaving just a single cottage standing in that area.

The fires of the 1920s, in a way cleared up some problems in Macatawa Park, making way for new owners to purchase double lots in the burnt areas and build larger cottages that complied with better building regulations. The rest, as they say, is history.

Long after L. Frank Baum's death and the loss of their former "The Sign of the Goose," L. Frank Baum's wife Maud once again traveled to his "fairyland", together with their son Robert Baum, in 1932. Maud Baum lived a long life, directly passing on stories of Macatawa to her eldest great-grandson Roger S. Baum (who authored the Forward to this book), who says she lived to see the blockbuster MGM film "The Wizard of Oz".

The Fate of the Steamer *Soo City*

The passenger steamer *Soo City* wound up the 1899 season on December 4, 1899. By 1908, the *Soo City*, which had helped during the Regatta of 1899, had been sold after a successful career ferrying passengers

between Chicago and its summer region of Macatawa Bay for 20 years. She was on her way to New Orleans, where she was to be put in service between that city and Texan ports. But the *Soo City* met its end in a cloak of mystery on the North Atlantic.

The Winchester News reported on December 5, 1908, that the *Soo City* encountered a gale on a trip to the gulf during the off-season. It had left Michigan City, Indiana under the command of Captain F.V. Dority of Milwaukee on November 1, 1908, for New Orleans. She took on coal and added four men to her crew at Ogdensburg, NY on November 11th. Also in NY, command was turned over to Captain John G. Dillon of Brooklyn. From there, the *Soo City* departed for a trip down the St. Lawrence River and then along the Atlantic coast to Velasco, Texas. But she was last reported at Quebec on November 19, and never heard from again.

She was first thought to have foundered in a violent winter storm that swept the Great Lakes and the North Atlantic on December 1 and 2nd, since several other boats on the lakes were sunk or driven aground in that gale.

Wreckage came ashore at Cape Ray, including a deck cabin and fittings and 16 life preservers all bearing the name "*Soo City*" or other marks identifying them as belonging to the lake steamer. But when life belts began drifting ashore with the names of both the *S. S. Stanley*, a Canadian icebreaker, and the *Soo City*, people began to think there had been a collision. The mystery deepened after the *Stanley* was found safe in Charlotte Town, Prince Edward Island. Nobody could explain how the vessel's life belts were mixed with those of the *Soo City*. No bodies were ever found. Sailors also wondered why the *Soo City* was still in the North Atlantic on Dec. 1 because it left Quebec on Nov. 14, and the boat was expected to reach its destination in Texas within ten days. The only theory was that the *Soo City* became disabled and drifted for days before the storm sank it.

In the tragedy the entire crew of the *Soo City* was drowned. At least 18 men were on board, with an unconfirmed report that the crew may have increased to 28 men in NY. She carried no passengers when she went down.

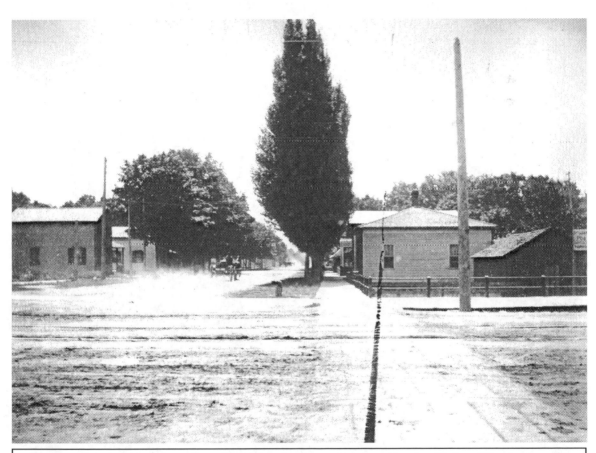

I believe this to be an image from Hattie's hometown Chicago suburb of Joliet, Illinois after she returned home. A one-horse cab can be seen pulling away at full gallop, perhaps after having returned the Talcott family back to their off-season life.

Hattie A. Talcott & Family

Hattie and Charles had another child, a daughter Persis, born in May 1901. They returned to Macatawa Park, with Persis, during the summer of 1902, and again during the summer of 1903 staying at the same cottage just a few doors from L. Frank Baum's cottage each time.

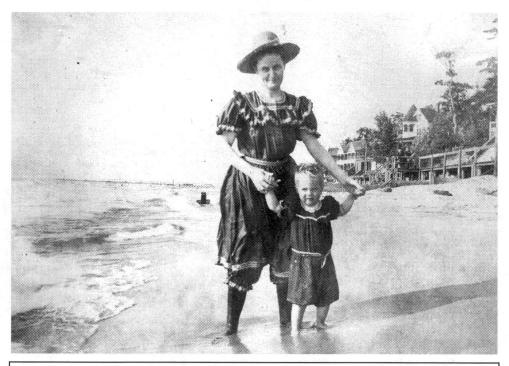

Persis Talcott & Susie Patterson, Sept. 4ᵗʰ, 1903, Macatawa Park, MI
With good eyes, Maud and L. Frank baum themselves can
be seen in the board walk alcove.

Charles H. Talcott, Hattie's husband, was a cashier at Will County National Bank in Joliet in 1899, earning promotions to ultimately become President of that very same bank. Hattie, born before the Civil War, lived a long and fulfilling life. She lived another 44 years, outliving her husband Charles, to whom this vintage photo album was originally gifted, by some 25 years. After Charles died Hattie took work as an insurance agent,

and Ethel as a typist. Hattie passed on in the warmth of Los Angeles, California, on December 1, 1943.

The Talcotts: Charles, Clarence, Ethel, Persis, Hattie and Raymond, December 8, 1902

Thanks to Hattie and the vintage photo album of her summer of 1899 that she left us with, a more colorful understanding of L. Frank Baum's summer vacation "The Wonderful Wizard of Oz" (and a bit later "Tamawaca Folks"), have all now become just a little bit richer.

Dorothy

One last thing about Hattie's photo album that is quite intriguing. Remember it was mentioned at the start of this book that it is widely believed L. Frank Baum's inspiration for his heroine Dorothy came from

Macatawa Park, and that although real-life Dorothy Hall from Macatawa Park later in life made claim to being the inspiration for Dorothy she was only 2 years old in 1899.

There are quite a few fascinating photos in the 1899 album including a young girl who does not appear to be directly related to the photo album's creator. One is at the very front of this book opposite the Introduction by Robert A. Baum and there are a few others throughout. There are some of her along the winding board walks into the woods, with other Macatawa residents, etc., and in almost all she is wearing a hat, a dress with dark stockings, and lace-up shoes, just like Dorothy in "*The Wonderful Wizard of Oz*".

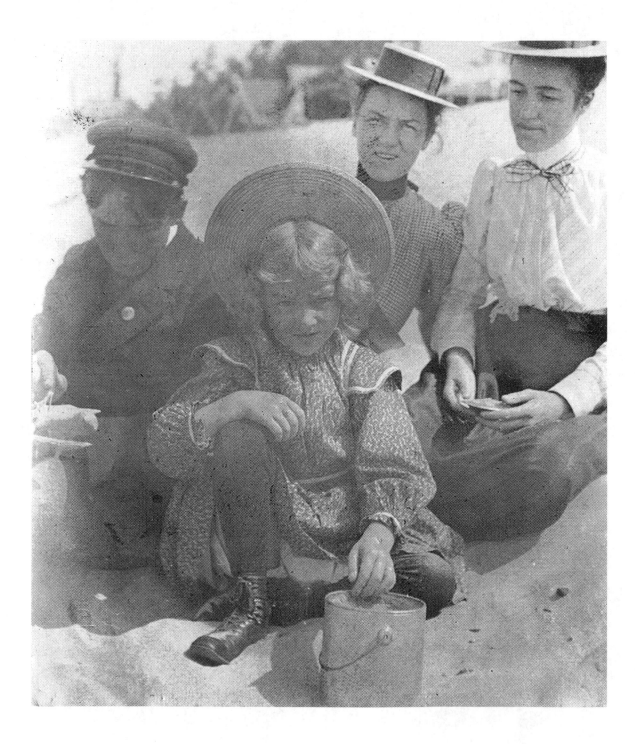

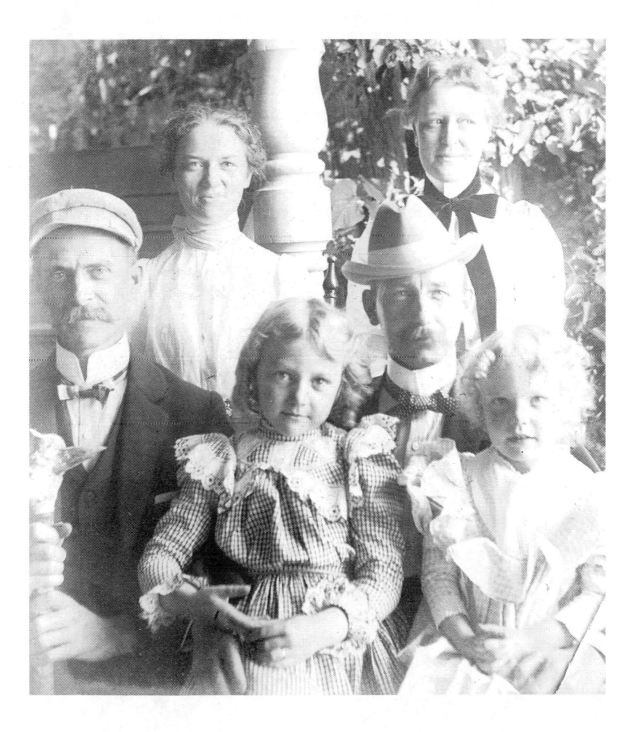

But perhaps most heart-stopping is the photo of that same young girl, in a gingham dress with checks of white and perhaps blue, being approached by a monkey. The young girl appears to be somewhat apprehensive as the monkey reaches out to her. It was THIS summer of 1899, at Macatawa Park, that helped inspire L. Frank Baum as he wrote *"The Wonderful Wizard of Oz"* and Hattie's cottage was just a few doors away. Might *this* girl in Macatawa in the summer of 1899 have been the 'first' inspiration for Dorothy, and could the cap-wearing monkey have been inspiration for winged monkeys, in our beloved *"The Wonderful Wizard of Oz"* . . . ?

On you, dear Mac., where stands my shack,
I'll ne'er by work or deed go back;
But ever will I drool they praise
And love thee well for all my days.

L. Frank Baum
(From the Rhapsody "To Macatawa")